IMAGES
of America

CHICAGO'S SOUTH SIDE
IRISH PARADE

IMAGES
of America

CHICAGO'S SOUTH SIDE IRISH PARADE

Bridget Houlihan Kennedy

ARCADIA
PUBLISHING

Published by Arcadia Publishing
Charleston, South Carolina

Printed in the United States of America

Library of Congress Control Number: 2009928711

For all general information contact Arcadia Publishing at:
Telephone 843-853-2070
Fax 843-853-0044
E-mail sales@arcadiapublishing.com
For customer service and orders:
Toll-Free 1-888-313-2665

Visit us on the Internet at www.arcadiapublishing.com

This book is dedicated to my mother, Mary Alice Loftus Houlihan, who embodies the spirit of the South Side Irish. And to my husband, Michael, who is both Irish and good looking. Thank you for all of your help, love, and support.

CONTENTS

ACKNOWLEDGMENTS

I would like very much to thank the families who started the South Side Irish Parade, for without them there would be no parade. A very special thanks to Marianne Coakley and George and Mary Hendry. Thanks also to Annie Coakley, Bess Hendry, Peggie and Bob Rafferty, Kathleen and Dennis Hughes, Mike and Mary Kean Coffey, Jack and Maureen Kelly, Mary Beth Sheehan, Jim Heffernan, Paul Poynton, Jeannette Kelly, George and Mary Ellen Nedved, Mike and Maura McDermott, M. Terry Donley, Phyllis Gannon, Jason Brown, Rosemary Bilecki, Tom Hynes, Beth and Dennis Hart, Mary and Larry Nitsche, Mike Houlihan, Cathy Fennell, Dan Hynes, Terry McEldowney, Art Morgan, Don Bowman, Kathleen Walsh Mulcahy, the South Side Irish Parade Committee, Scott and Maureen McWilliams, the U.S. Army Corps of Engineers, Paula Riggins, Bridget McLaughlin, Fr. Mike O'Keefe, Mike Kennedy, Margaret and Jim Smith, Kathleen Houlihan, David Motzenbecker, Marty and JoAnn Houlihan, Molly and Peter McDermott, Nora Houlihan, and Mary Alice and Dan Houlihan. South Side Irish Parade Committee photographs are credited to John Hanley, Don Bowman, Art Morgan, and George Todt.

INTRODUCTION

Back in the early 1950s, Chicago South Side resident George Hendry was one of several young children who marched in the St. Patrick's Day Parade down 79th Street in Chicago. The Southtown Parade began on March 15, 1953, and lasted for seven years before being moved to downtown Chicago by Mayor Richard J. Daley in 1960. Daley combined the Southtown and West Side St. Patrick's Day Parades into one main parade downtown. The move essentially ended any type of neighborhood St. Patrick's Day Parade for Chicago.

During the summer of 1978, Hendry was reminiscing about his 79th-Street-Parade days to best friends Pat and Marianne Coakley and Marianne's parents, John and Frances McKenna. Hendry marched in the Southtown Parade as a cub scout, little leaguer, and altar boy and expressed disappointment that their children would never get to experience a neighborhood St. Patrick's Day parade as he once had.

Over the following months, Hendry began to muse about resurrecting a neighborhood St. Patrick's Day Parade on the South Side, but many of his friends dismissed his talk as simple Irish blarney.

Undaunted, Hendry held the first South Side Irish Parade meeting in his basement on March 10, 1979. His children, Jack, 9; George, 6; and Bess, 2; were assigned to go around the block and invite their friends to the meeting. In all, 17 children ages 2 to 10 years old came and listened to Hendry speak about the Southtown Parade and the valuable memories he had of playing a role as a child. He ended his speech by asking the children if they wanted their own parade. With a resounding "Yes!" and high-fives all around, the first South Side Irish Parade was held one week later on Sunday, March 17, 1979.

A crazy, fun-filled week ensued as preparations for the parade quickly began. Snapping up scissors, glue, glitter, and construction paper, the children created signs on poster boards that were then stapled to dowel rods and yard sticks. Creative mothers pulled costumes together with bed sheets, bathrobes, and any green outfits they could find, which provided the parade with its own St. Patrick, St. Cajetan—in honor of the local parish—a leprechaun, and the first and only Queen of the Parade, a title held by 9-year-old Eileen Hughes.

The night before the parade, fathers Pat Coakley, Dennis Hughes, and Mike Hayes met in the Hendrys' basement, and with the help of Mary Hendry, constructed the parade's first float—a baby buggy with a box covered in green construction paper on top.

Although the weather was dreary, with snow and puddles on the ground, it didn't stop the kids from grabbing their homemade signs, some of which read "Bring Back Saint Pat!"—the parade's first theme—and running out the door. Pat Coakley dubbed the children the "Wee People of Washtenaw and Talman," in honor of the two streets that served as the original parade route and home addresses of the participants. Over the years, the group's name changed and they were commonly referred to as the "Wee Folks of Washtenaw and Talman."

Neighbors, friends, and relatives came out to cheer on the Wee People, as they were notified by small announcements placed in their mailboxes earlier that week. The parade kicked off at 3

p.m. sharp in the Coakleys' driveway, and the Wee People marched twice around the blocks of Washtenaw and Talman Avenues. Dennis Hughes rigged a stereo speaker to the top of his car, so that Irish music could be heard as it slowly followed the marchers along their route. A reporter from the *Southtown Economist* came by to snap some photographs for the following day's edition. After the parade, the children went back to the Hendry's basement for cookies, Twinkies, and 7-Up, while the parents warmed up with Irish coffee. Later that evening, parents went to the Coakleys' for a corned-beef sandwich, a pint, and a chance to exchange stories about how great the day had been.

The following day, the *Southtown Economist* ran a photograph of the parade on its front cover. This sparked phone calls to the Hendrys and Coakleys from neighbors asking if there would be another parade the following year and how they could get their children involved. With the exception of George Hendry, nearly every parent involved in the first parade did not foresee the parade happening a second year. However, as the year moved forward, neighbors began calling again, and the demand for a second parade was clear.

The second South Side Irish Parade was held on Sunday, March 16, 1980, but the route changed from walking around the blocks of Washtenaw and Talman Avenues, to walking around Kennedy Park at 113th and Western Avenue.

Although numerous people called, wanting to get involved, Marianne Coakley later recalled she was stunned at the number of people who showed up at the park. In one year, the number of spectators grew from 50 to 500. There were now boy scouts and bagpipers marching, and the St. Cajetan School band played as spectators entered the park. The word was out that a neighborhood parade was rising again, and the excitement was contagious. The parade was beginning to feel like it belonged to the locals and was quickly becoming a source of pride among the South Side Irish.

A major turning point for the parade came in its third year on March 15, 1981. It was the first year the parade marched down Western Avenue from 103rd to 113th Streets. The popularity of the parade, and the number of entries, required that it march down a street, instead of circling a park. Marching bands finally joined the lineup, and Wee People Sean Crowe, 1; Bess Hendry, 4; and Annie Coakley, 5; were named grand marshals of the parade, signifying that the parade would be first and foremost a family affair.

Marching down Western Avenue proved to be difficult, as the City of Chicago would only close the southbound lanes for participants. Northbound lanes remained open to traffic. Police protection was not available, so instead, crowd control and traffic management were left to civilian crossing guards and parade marshals, according to the *Southtown Economist*. That year, the parade had nearly 1,500 marchers, and a crowd of approximately 8,000 came out to watch. Mounted police had been promised, parade organizers told the *Southtown Economist*, but were pulled from the event to work crowd control at the Shamrock Shuffle in Lincoln Park. Off duty Chicago police officers and sheriff's police pitched in to provide much-needed security, while Merrionette Park Police directed traffic. The *Chicago Tribune* later reported the lack of police protection was due to a "bitter feud" between Chicago mayor Jane Byrne and Cook County assessor Thomas Hynes, who was Democratic committeeman for the 19th Ward.

The 1981 parade was also the first year that the St. Cajetan Church celebrated a mass honoring St. Patrick, and held a post-parade party with food and music at St. Cajetan Memorial Hall. The trilogy of "Pray, Parade, and Party" was quickly born and became a tradition for many neighborhood families on parade day.

The following year, 1982, police protection was present and traffic was closed to both sides of Western Avenue. By the fifth year, the crowd rose into the tens of thousands. Once the parade found a home on Western Avenue, the route never changed. Eventually, politicians got past the intense rivalry between the downtown and South Side parades and began requesting slots in the South Side parade. In keeping with the theme that the parade should be first and foremost about families and children, politicians were never placed in the front of the parade. Instead, they were put in the middle or at the end.

Grand marshals also became a parade fixture as the years progressed. For the first three years of the parade, the Wee Folks of Washtenaw and Talman held the title. In 1982, the parade committee reached out and asked Tim McCarthy to be their grand marshal. McCarthy, a resident of the South Side and a secret service agent, was assigned to the protection detail for President Ronald Reagan and was shot during the failed assassination attempt in 1981. Since then, various organizations have held the title of grand marshal, including the Children's Memorial Hospital of Chicago, Veterans of World War II, and Mount Carmel High School and the Carmelites. In 2004, the parade committee added a special honoree as well as a grand marshal, so that two organizations could be highlighted in the parade. That year, grand marshal honors went to the Cystic Fibrosis Foundation, while St. Rita of Cascia High School was named special honoree, since the school was celebrating its 100th anniversary in Chicago.

Over the years, the parade became larger and larger, averaging between 250,000 to 300,000 spectators each year. In 2003, an estimated 375,000 people were in attendance, according to the *Chicago Tribune*. Although the City of Chicago supplied police protection for all the parades beginning in 1982, the local parade committee was responsible for organizing the event's financial support and held annual fundraisers to cover the various logistical costs such as bagpipers, buses for school marching bands, and cleanup after the festivities.

Neighborhood families also got into the spirit of hosting post-parade parties and soon there were numerous open-house parties for friends and relatives. Many families opened their doors to anyone, and strangers were met with food, drink, and smiles. In the last few years of the parade, people from the North Side were provided with a means of joining in the tradition through the numerous buses sponsored by prominent bars and pubs.

But eventually the parade became too much for the neighborhoods of West Morgan Park, Beverly, and Mount Greenwood to handle. On March 25, 2009, after 31 successful years, the parade committee announced the South Side Irish Parade would not be back in its current form in 2010. The large volume of people became more than the neighborhoods could reasonably handle, and it had put a large strain on the community and the parade committee itself.

While the parade may be over, the history of this local institution provides hope that while there is no doubt that the South Side Irish spirit will live on forever, the parade may one day march again.

One

BRING BACK ST. PAT

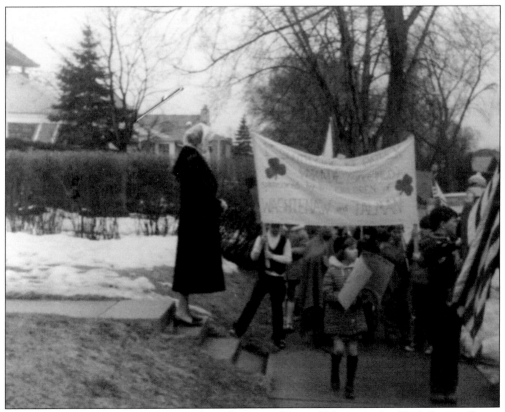

Sr. Catherine Ann Cartan, RSM, stands on the steps of Pat and Marianne Coakley's front walkway, as seven-year-old Colleen Kelly leads the "Wee People of Washtenaw and Talman" during the first South Side Irish Parade on March 17, 1979. This was the first parade on the South Side since the Southtown St. Patrick's Day Parade, which marched upon the street rails of 79th Street. (Courtesy of Marianne Coakley.)

ANNOUNCEMENT

The First Annual Southside 60
SAINT PATRICK'S DAY PARADE (since 1959)
Sponsored by: The Wee People of
 Washtenaw and Talman

Look out your window or stand on your porch
and cheer on the Wee Ones! Kick off at
3:00 p.m. Saturday, March 17th in front
of 10907 S. Washtenaw. The parade will
march twice around the sidewalk on the
odd numbered side of Washtenaw and the
even numbered side of Talman.

HAPPY SAINT PATRICK'S DAY!

Typewritten announcements were placed in mailboxes of residents who lived on the parade route, encouraging them to come out of their houses and cheer on the Wee People during the parade. The first parade route went around the long blocks of Washtenaw and Talman Avenues, between 109th and 110th Streets, because many of the children weren't old enough to cross the street. (Courtesy of Marianne Coakley.)

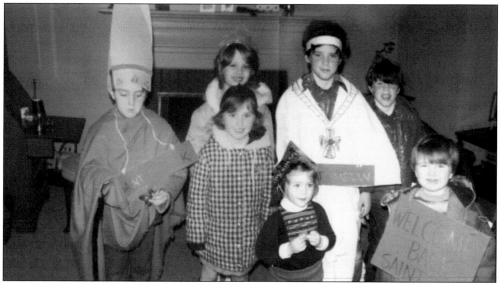

The Wee People pose for a photograph just before the parade begins. Tim Kelly, 9, far left, is dressed as St. Patrick, while Jack Hendry, 9, third from right, is dressed as St. Cajetan, in honor of the local parish. Other Wee People standing include, from left to right, Colleen Kelly, 7; Tara Henry, 8; Bess Hendry, 2; George Hendry, 6; and Mickey Kelly, 5. (Courtesy of Mary Hendry.)

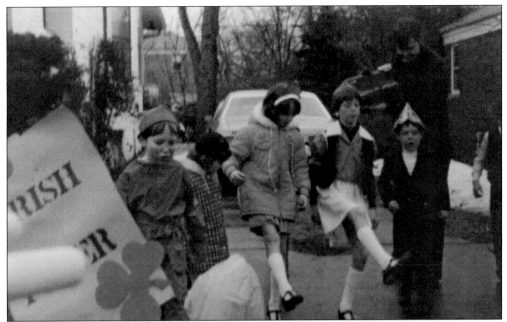

The Wee People kicked off the parade in style with some Irish dancing. From left to right are Michael Hayes, 7; Colleen Kelly, 7; Tara Henry, 8; Eileen Hughes, 9; and Kevin Coakley, 6. Eileen Hughes was the parade's first and only queen. Music was provided for the parade by her father, Dennis Hughes, by rigging a speaker to the top of his van and following the kids around the block. (Courtesy of Marianne Coakley.)

Parade attendees John and Frances McKenna wave their American and Irish flags as they join daughter Marianne Coakley at the beginning of the parade. John and Frances lived next door to their daughter and were part of the first conversation about having a parade with George Hendry and Pat Coakley in the summer of 1979. (Courtesy of Marianne Coakley.)

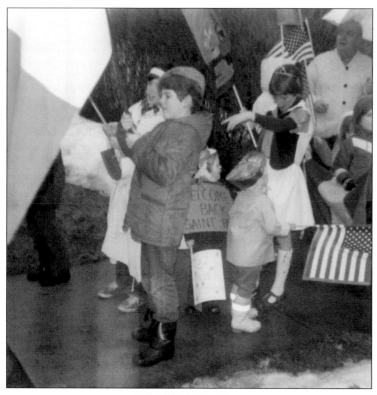

Getting organized for a parade can be hard, especially when the majority of participants are under the age of 10. Michael Coffey, 8, stands with a large Irish flag, ready to go. Behind him, Annie Coakley, 3, and Bess Hendry, 2, look up to Parade Queen Eileen Hughes, 9. (Courtesy of Mary Hendry.)

A marching we will go! The cold and dreary weather did not stop the Wee People from stepping off for their first neighborhood South Side Irish Parade. The group carried American flags, Irish flags, and posters that read, "Bring Back St. Pat!"—the theme of the first parade. In this photograph from left to right are Bess Hendry, Eileen Hughes, Emma Kean, Cara Kean, Jane Coffey, and Brian Coffey. (Courtesy of Mary Hendry.)

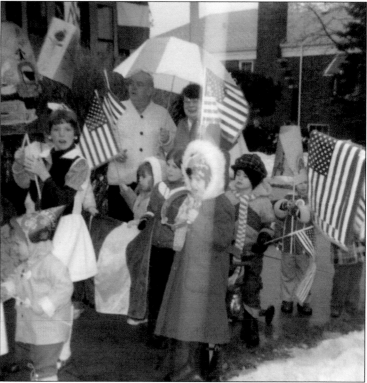

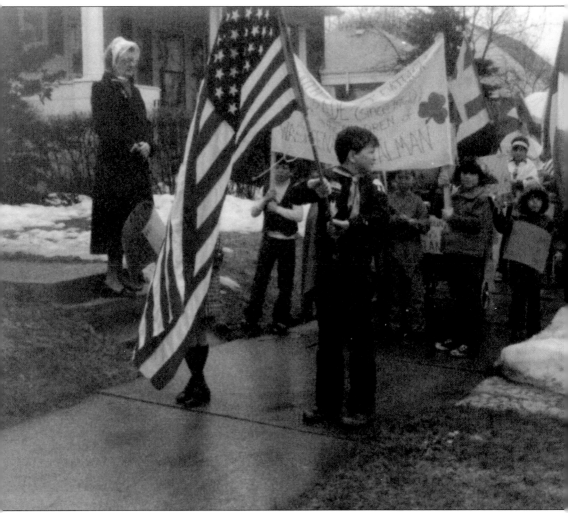

And they're off! John Mackey, 10, leads the parade march down Washtenaw Avenue and 109th Street in Morgan Park. About 50 spectators, made up of neighbors, family, and friends, came out to watch the parade. Wee People Dennis Hughes and George Hendry held a large sign that read, "1st South Side St. Patrick Parade (since 1960). Sponsored by the Children of Washtenaw and Talman." (Courtesy of Kathleen Hughes.)

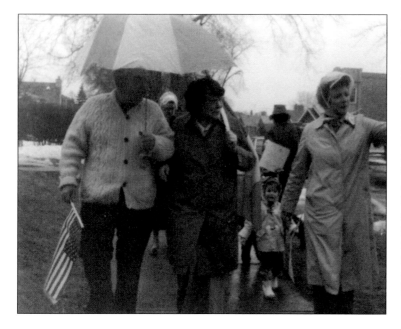

John and Frances McKenna join the parade march with Mary Hendry, while Mary's daughter, Bess, keeps up behind her. Mary's husband, George, helped co-found the parade with Pat Coakley, son-in-law of the McKennas. None of them seemed to mind the cold and drizzle that came with this first parade day. (Courtesy of Kathleen Hughes.)

Once the parade was over, the Wee People—including seven-year-olds P. J. Schickel and George Hendry—gathered at the Hendrys' house on Talman Avenue for refreshments and treats, while the grownups warmed up with some Irish Coffee. The week before the parade, the children worked hard on their homemade signs to carry down the route with pride. (Courtesy of Mary Hendry.)

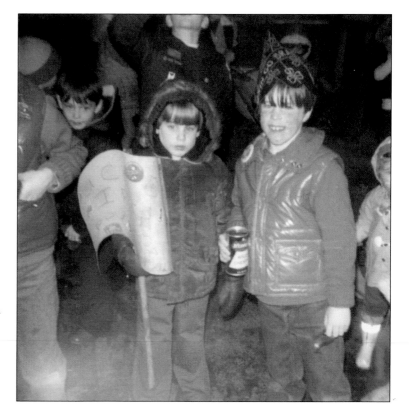

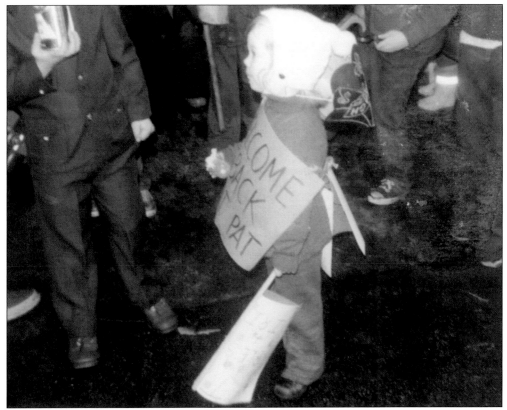

Annie Coakley, 3, enjoys her Twinkie after the parade. A poster hanging on her reads, "Welcome Back Saint Pat." It had been 19 years since the South Side had seen a St. Patrick's Day Parade. In 1960, Mayor Richard J. Daley moved the 79th Street Southtown Parade to downtown Chicago. The South Side Irish Parade was a resurrection of the Southtown one, created so that neighborhood children could enjoy their own festivities. Below, Annie stands next to the parade's first float—a baby buggy with a box on top, covered with the county flags of Ireland. Not thinking there would be another parade, Mary Hendry tossed this buggy in the garbage later that year. When the parade came back in 1980, another baby buggy was used. It was pushed by Marianne Coakley in every parade through 2009. (Courtesy of Mary Hendry and Marianne Coakley.)

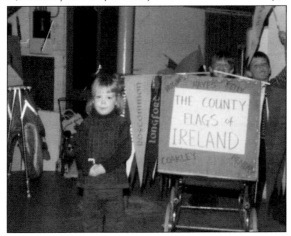

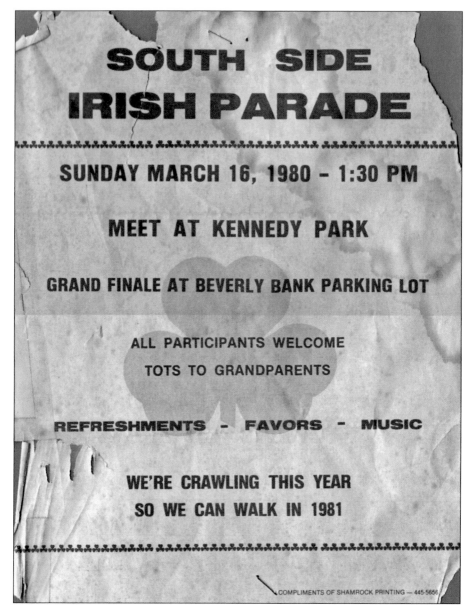

SOUTH SIDE IRISH PARADE

SUNDAY MARCH 16, 1980 – 1:30 PM

MEET AT KENNEDY PARK

GRAND FINALE AT BEVERLY BANK PARKING LOT

ALL PARTICIPANTS WELCOME
TOTS TO GRANDPARENTS

REFRESHMENTS - FAVORS - MUSIC

WE'RE CRAWLING THIS YEAR
SO WE CAN WALK IN 1981

COMPLIMENTS OF SHAMROCK PRINTING — 445-5656

The parade was back for a second year on March 16, 1980, thanks to an overwhelming demand from residents in the neighborhood. The parade brought back people involved in the 79th Street Southtown St. Patrick's Day Parade, including police captain Bill Hennessy and his famous Killaloe Bird. The number of participants increased greatly this year. There were now bagpipers, boy scouts, and members of the Veterans of Foreign Wars (VFW) in the marching line. The number of spectators rose as well. In its first year, about 50 people came out of their houses to watch the parade, but by the second year, the number jumped to approximately 500. This year, the parade route moved from around the blocks of Washtenaw and Talman to around Kennedy Park at 113th and Western Avenue. As participants marched, the St. Cajetan's School band, led by director Frank Manna, played music in front of the Field House. The parade ended at the Beverly Bank parking lot, where people gathered to listen to Terry McEldowney sing. (Courtesy of Marianne Coakley.)

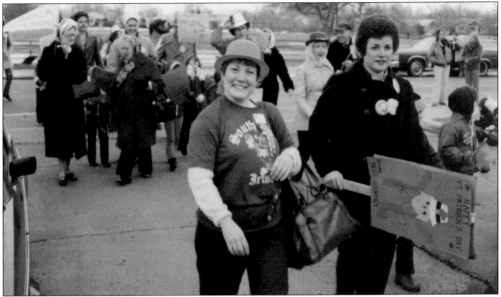

Marianne Coakley and Mary Hendry head to the marching line at Kennedy Park for the second parade. Coakley later said she was shocked when she turned the corner and saw the large number of people at the park. (Courtesy of Mary Hendry.)

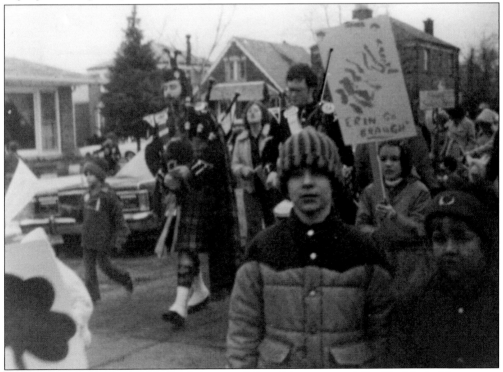

A bagpiper and drummer help lead the crowd from Marianne and Pat Coakley's driveway on Washtenaw Avenue over to Kennedy Park, just a few blocks away. Next to them, a young girl holds a sign that says, "Erin Go Braugh," the Anglicization of a Gaelic phrase meaning "Ireland forever." (Courtesy of Marianne Coakley.)

South Side residents Paul and Maureen Nitsche take their daughter, Tracy, and join the marchers on their way to Kennedy Park. Although not as dreary as the weather at the first parade a year before, it was still chilly enough that some children and parents wore winter coats, scarves, and hats to the parade. (Courtesy of Marianne Coakley.)

While marching to Kennedy Park, some parade attendees may have seen this rather large leprechaun walking with them. Decked out in a green suit with an orange beard and walking stick, this Irish elf stopped long enough to wave to the camera and get his picture taken. (Courtesy of Marianne Coakley.)

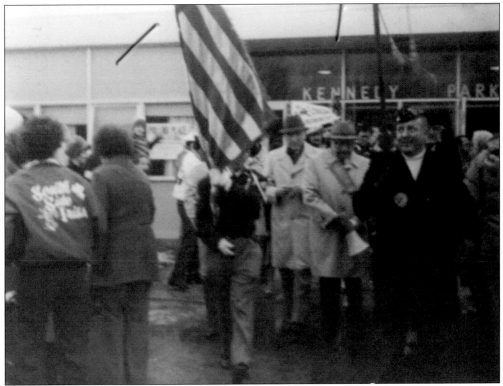

Chicago police captain Bill Hennessy holds a bullhorn as people gather for the parade at Kennedy Park. Hennessy was known for having a Killaloe Bird, a mythical bird that flew backwards and brought good luck, on his shoulder. Hennessy was instrumental in the 79th Street Southtown St. Patrick's Day Parade that marched from 1953 to 1960. (Courtesy of Marianne Coakley.)

Sometime during the second year of the parade, the "Wee People" became known as the "Wee Folks," a moniker that has remained ever since. From left to right are Wee Folks Dennis Hughes, Eileen Hughes, Patrick Coakley, and Bess Hendry, waiting for the parade march to begin. (Courtesy of Mary Hendry.)

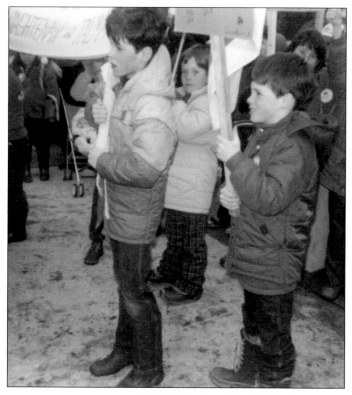

Wee Folks Jack Hendry, Patrick Coakley, and George Hendry hold homemade signs while marching in the parade. The parade announcement invited all children to create their own posters for the parade. It asked that kids bring their artwork to Coakley's driveway the day before the parade. There, Pat Coakley and George Hendry could help attach sticks to the posters so they could be carried high. (Courtesy of Mary Hendry.)

Parade cofounders George Hendry and Pat Coakley share drinks and smiles with good friend Dennis Hughes, who was involved in the parade from the beginning. Behind George is Brian Crowe, working as one of the many parade marshals and whose kids marched along with the Wee Folks. (Courtesy of Mary Hendry.)

People came out to stand on the steps and any porch space available behind Sheahan's Pub to hear South Side resident Terry McEldowney sing for the crowd below. Once the parade march ended at Kennedy Park, everyone walked over to the Beverly Bank parking lot for refreshments, favors, and music. Some children performed Irish dances, as parents talked about how great the parade had been again. A portable speaker and microphone were rigged up for McEldowney to use when singing for the crowd full of children, parents, and grandparents. (Courtesy of Mary Hendry.)

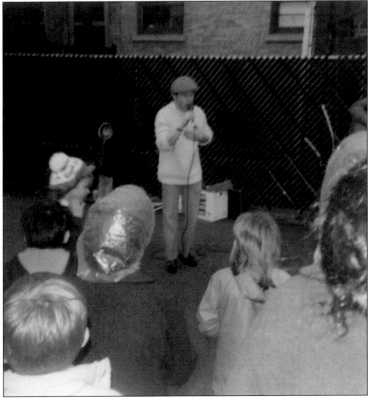

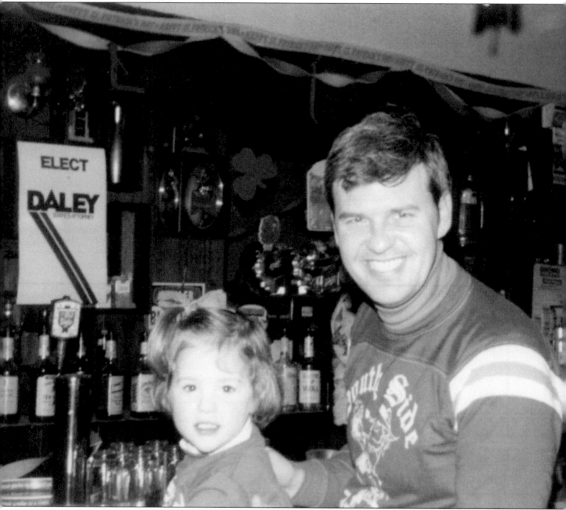

Wee Folk Bess Hendry sits at the bar of the Western Pump with her father, parade cofounder George Hendry. An "Elect Daley" sign hangs at the bar, supporting Richard M. Daley, who was running for Illinois state's attorney at the time. The Western Pump was owned by Mike Corcoran and was a favorite watering hole for many of the Wee Folk parents. Many of them frequented the pub after several parades over the years. Even with the first and second parades considered to be great successes, no one could have imagined at that time what George Hendry had in mind for the third year—to march down Western Avenue. (Courtesy of Mary Hendry.)

Two

MARCHING DOWN
WESTERN AVENUE

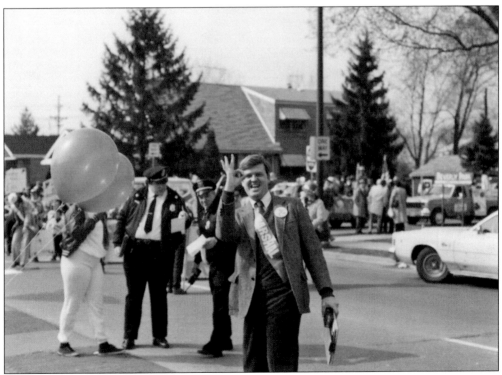

Parade cofounder George Hendry gives the A-OK sign as he walks to the parade. The year 1981 was a huge turning point, because it was the first year the parade marched down Western Avenue. Moving the parade to the busy street proved difficult, as the City of Chicago would only allow the southbound lanes to be closed for the parade. Northbound lanes remained open to traffic on the busy street. (Courtesy of Mary Hendry.)

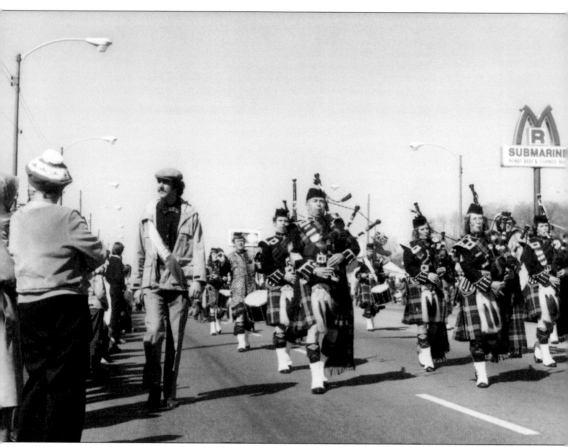

What's a St. Patrick's Day Parade without some music? Securing bagpipers and marching bands for this parade was key, said parade cofounder George Hendry. In 1981, the Chicago Stock Yard Kilty Band led the parade down Western Avenue and has done so every year since. The band was lead by pipe major Dick Haggerty of Haggerty Car Dealers. The band was originally formed by brothers Robert and James Sim in Chicago. The Stockyard Kilty Band is one of the oldest continuous pipe bands in the country. In 1921, Robert Sim formed the British Legion Pipe Band with his brother. By 1925, the Chicago Stock Yard American Legion Post No. 333 was looking for a musical unit, and the two became affiliated. Sim changed the band's name to the Chicago Stock Yard Kilty Band in 1926. Just a few years later, in 1931, some members broke off and formed a new band, the Chicago Highlanders, a pipe band that is still around today. (Courtesy of Mary Hendry.)

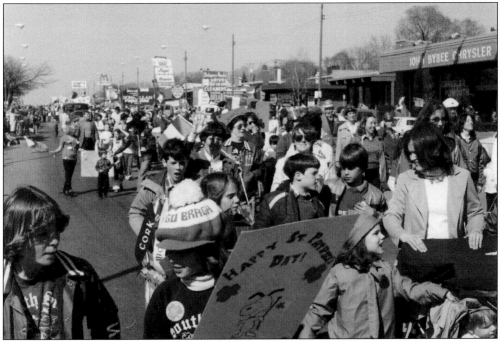

The 1981 South Side Irish Parade stepped off from 103rd Street and Western Avenue, where it headed south until 113th Street and disbanded at Kennedy Park. There were approximately 5,000 marchers, 50 vehicles, and 30 floats in the parade, which covered a wide spectrum of participants, including Fahey Flynn from Channel 7, O'Connor Ford, and Bill and Norm's Arco Service Station. (Courtesy of Mary Hendry.)

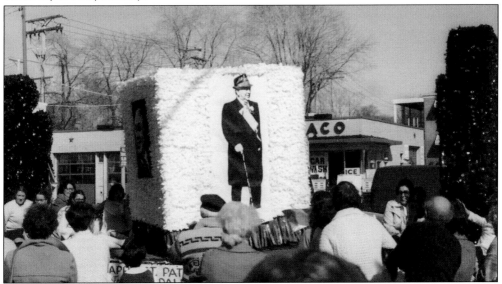

The 11th Ward float wished everyone a happy St. Patrick's Day with photographs of one of the most famous Irish mayors of Chicago, Richard J. Daley—ironic since the former mayor was the one who pulled the plug on the 79th Street Southtown St. Patrick's Day Parade in 1960 and moved it downtown. The South Side Irish Parade began as a revival of the 79th Street Parade. (Courtesy of Mary Hendry.)

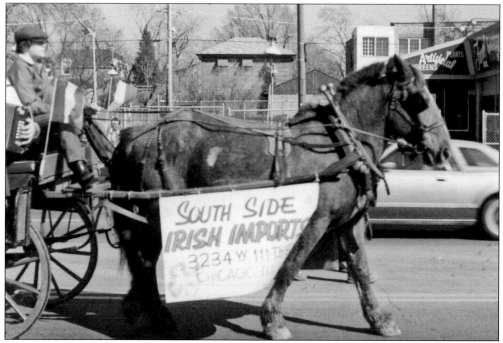

In 1981, South Side Irish Imports joined the parade lineup, as did a young marching band. What is most notable about these images is the cars in the background. That year, the City of Chicago would not allow both sides of Western Avenue to be closed to traffic for the parade. Cars, buses, and trucks drove in the northbound lanes, while parade marchers, many of whom were children, walked southbound. The City of Chicago also denied police protection for the parade in 1981. Crowd control was left to civilian crossing guards, and off-duty Chicago police and sheriff's officers. According to the *Chicago Tribune*, the lack of police protection was due to a feud between Chicago mayor Jane Byrne and Cook County assessor Thomas Hynes, who was Democratic committeeman for the 19th Ward. (Courtesy of Mary Hendry and Marianne Coakley.)

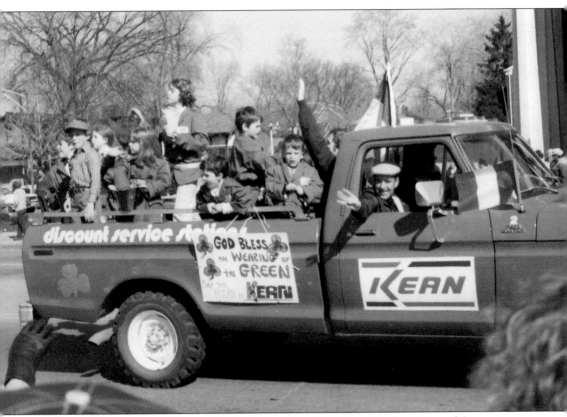

Always strong supporters of the parade, family members of the Kean Brothers Gas and Convenience Stores waved to the crowd as they rode in the company pickup truck. On the side of the truck is a family sign that reads, "God Bless the Wearing of the Green, Say the Folks at Kean!" Kean Gas was one of the first businesses to support the parade, and by doing so, it influenced other local businesses to do the same. The blue pickup truck became a staple of the parade in the early years. Here Jim Kean drives the truck in the 1981 parade, while Jeff Reynolds waves to the crowd. From left to right are Michael Coffey, Patrick Nash, Cara Kean, Emma Kean, Leah Kean, Josie Coffey, Brian Coffey, Raleigh Kean, and Mike Coffey. (Courtesy of Mary Hendry.)

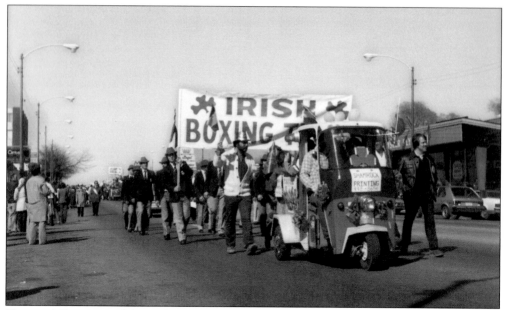

Shamrock Printing and the Irish Boxing Team marched proudly in the 1981 parade. About 1,500 entries marched in the parade that year, including Pipe Covers Union Local 17, the Irish Fire Brigade, the Emerald Society, Winston's Sausage Company, Town Liquors, Three's Company Interiors, and Old Brass Tap. (Courtesy of Mary Hendry.)

The parade was blessed with the luck of the Irish in 1981, as temperatures soared into the 60s with plenty of sunshine. Here the Wee Folks walk together while pushing their baby buggy float down Western Avenue. From left to right are parade cofounder George Hendry with Marianne Coakley, Pat Hayes, and Mary O'Brien. (Courtesy of Mary Hendry.)

South Side resident Dick Norris keeps the young marchers safe, as he walks the parade route with the Wee Folks. Norris was one of the many volunteer parade marshals who helped with crowd control at the 1981 parade. Marchers holding an American, Irish, and City of Chicago flag join the Wee Folks on the route. (Courtesy of Mary Hendry.)

With the parade winding down, South Sider Ed Austin gives his daughter, Colleen, a lift up on his shoulders, as the parade marches toward the Beverly Bank parking lot for the grand finale. Behind him is another daughter, Eileen, who walks with her grandfather, Bud DuLude. (Courtesy of Mary Hendry.)

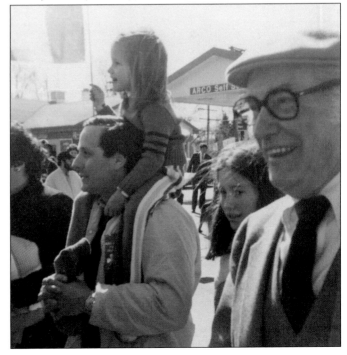

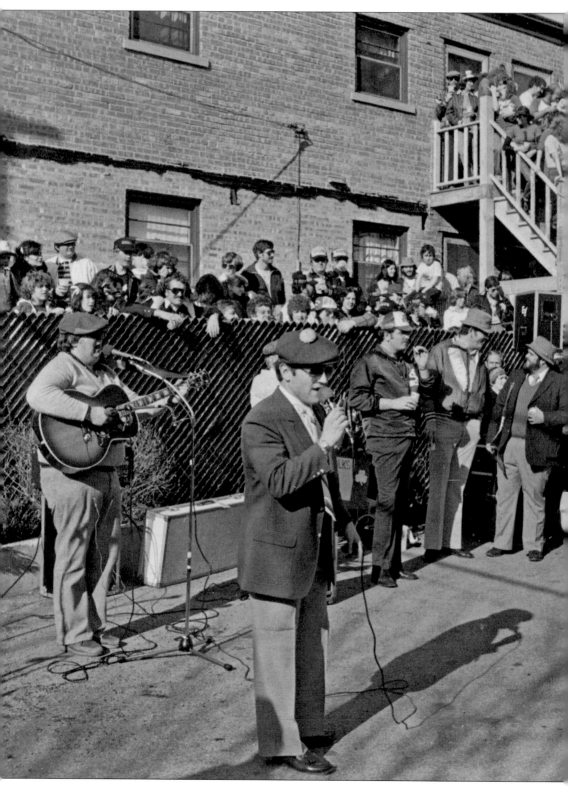

Irish singers Terry McEldowney and Whitey O'Day, on guitar, entertain a large crowd of children and adults in the Beverly Bank parking lot behind McNally's, an Irish bar on Western Avenue, in 1981. McEldowney is famous for cowriting the South Side Irish Song with Tom Walsh and Tom Black. The song has been sung at the parade for years, and many know its famous chorus: "We're the South Side Irish, as our fathers were before / We come from the Windy City, and we're Irish to the core / From Bridgeport to Beverly, from Midway to South Shore / We're the South Side Irish—let's sing it out once more!" (Courtesy of Marianne Coakley.)

2nd
3rd 1st SOUTH SIDE ST PATRICK PARADE (since 1960) sponsored by the CHILDREN of WASHTENAW and TALMAN

Kathleen and Dennis Hughes's van rides away from the 1981 parade with a banner from the Wee Folks of Washtenaw and Talman. The banner was originally carried in the first and second parades. By the third parade, the numbers had been crossed out to read that it was the third South Side St. Patrick's Day Parade since 1960. The 1981 parade was a huge success, and by 1982, both lanes of traffic on Western Avenue were closed for the parade. Police protection was also given, and the parade would continue to march down Western Avenue from 103rd to 115th Streets until 2009. (Courtesy of Mary Hendry.)

Three

GRAND MARSHALS AND SPECIAL HONOREES

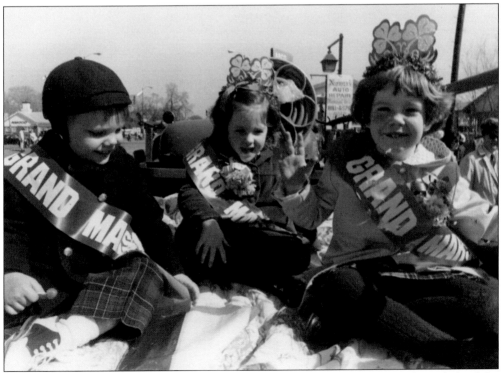

From 1979 to 1981, the Wee Folks of Washtenaw and Talman served as grand marshals of the parades. In 1981, the parade committee chose Sean Crowe, 1; Annie Coakley, 5; and Bess Hendry, 4; to lead the parade. The three children represented the Wee Folks and signified that children and family would always be at the heart of this parade. (Courtesy of Mary Hendry.)

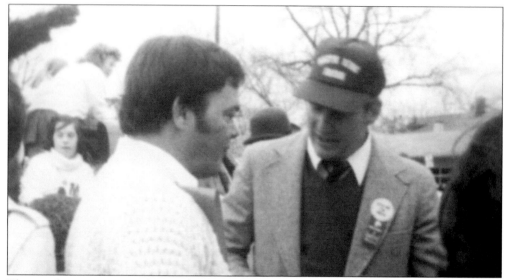

The parade committee was honored in 1982 to have South Sider Tim McCarthy, top right, serve as grand marshal. This was the first time the parade committee went outside of its members and asked someone new to hold the title. Less than a year before, on March 30, 1981, McCarthy was working as a secret service agent for President Ronald Reagan when gunman John Hinckley Jr. attempted to assassinate the president. McCarthy turned in to the line of fire and took a bullet in his chest. He fully recovered and was able to serve as grand marshal the following year. McCarthy is seen talking with friend Bob Callaghan in the top image and is handing out balloons to the Wee Folks with his wife, Carol, in the picture below. (Courtesy of Peg Rafferty and Mary Hendry.)

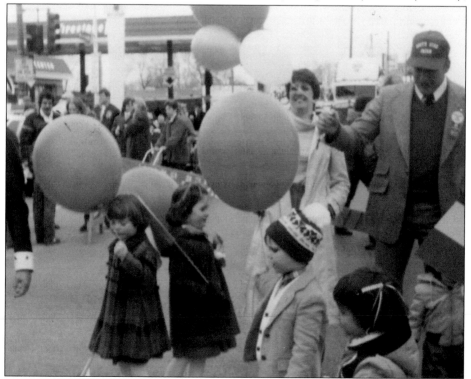

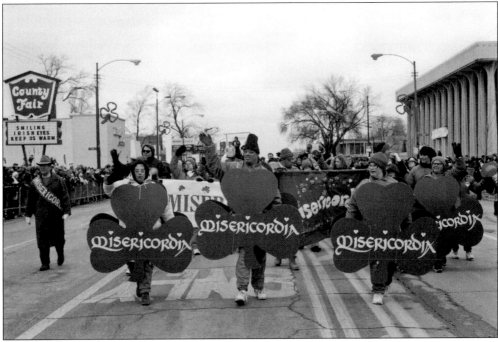

In 1986, the Misericordia Heart of Mercy Homes served as grand marshal. Operated by Sr. Rosemary Connelly, RSM, and the Sisters of Mercy, Misericordia Homes supports approximately 550 children and adults with mild to profound developmental disabilities. The organization, located on the north side of Chicago, provides physical, occupational, and speech therapy, as well as residential placement, job training, and employment opportunities for its residents. While serving as grand marshal in 1986, the group encountered a small problem when the transmission of their float burned out, and they had to abandon it. The loss of a float did not stop these determined residents, as they proudly marched the rest of the parade route. (Courtesy of the South Side Irish Parade Committee.)

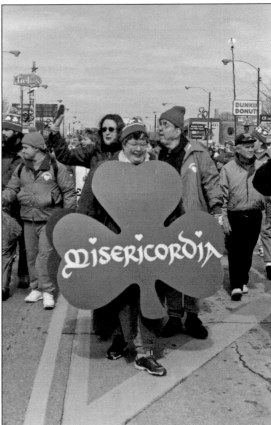

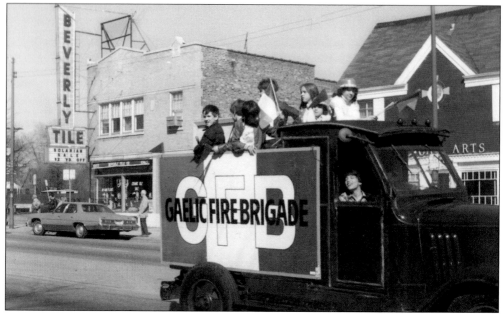

In 1981, the Gaelic Fire Brigade was one of the many participants to join the parade's line of march down Western Avenue. The organization was honored as grand marshal in 1984. Three hundred brigade members marched while representing the parade's theme of "Kith. Kin. Community. Country." (Courtesy of Mary Hendry.)

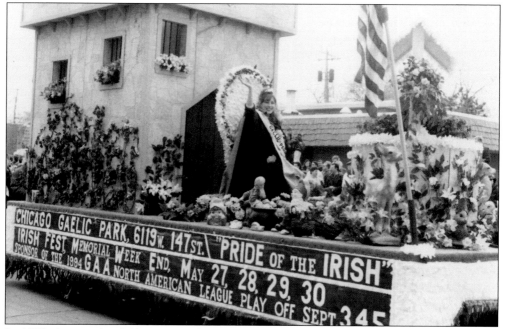

In 1987, the people of Chicago Gaelic Park were honored as grand marshals of the parade. Established in 1985, Chicago Gaelic Park was created to promote and foster Irish music, sports, and culture. Although there was no South Side Irish Parade Queen, Gaelic Park held their own queen contest, and winners were featured in the parade. (Photograph by Don Bowman; courtesy of the South Side Irish Parade Committee.)

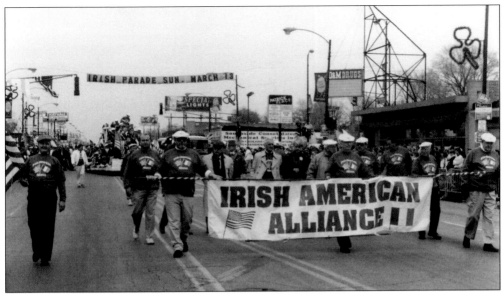

In 1994, the Irish American Alliance served as the parade's grand marshal. The nonprofit social club was founded in 1990 and has an affiliated charitable corporation. The club also sponsors various activities and events for its approximately 300 members, many of whom live on the South Side and in the South Suburbs. (Courtesy of the South Side Irish Parade Committee.)

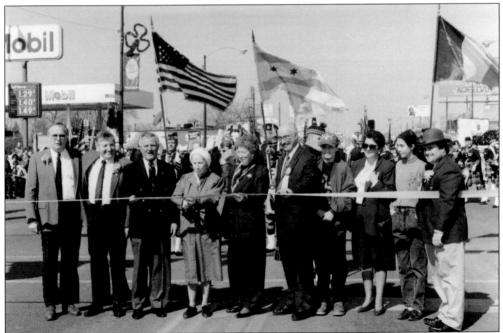

American, Chicago, and Irish flags waved as the Erin Homes were honored as grand marshals in 1995. Since 1980, the Erin Homes provided shelter for mentally disabled women over the age of 18. Mary McPhillips, who started Erin Homes, cuts the parade ribbon to kick off the celebration. Sean McCarthy, second from left, and Kevin Nedved, far right, served as coordinators of the parade. It was the only year the parade committee had two people serve in the position. (Photograph by Don Bowman, courtesy of the South Side Irish Parade Committee.)

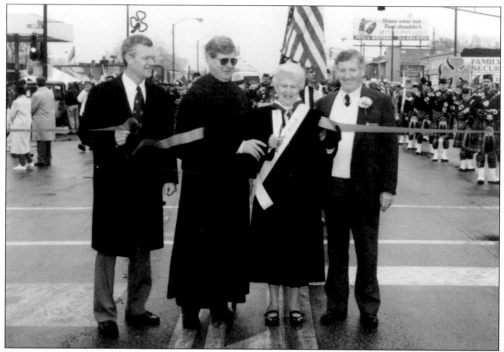

In 1996, the Sisters of Mercy and the Augustinians shared the title of grand marshal. Approximately 380 Sisters of Mercy were led by Sr. Lucille McKillop, president of the Sisters of Mercy Chicago regional community, in the parade. Local Augustinians were led by Rev. William Sullivan, who originally grew up in St. Cajetan Parish. Sullivan was the director of the Augustinian retirement home in Olympia Fields. McKillop and Sullivan kicked off the parade by sharing ribbon-cutting duties with parade committee members Bill Letz, left, and Sean McCarthy, right. The Sisters of Mercy were celebrating their 150th year in Chicago, while the Augustinians celebrated their 200th year coming to America. (Photograph by Don Bowman, courtesy of the South Side Irish Parade Committee.)

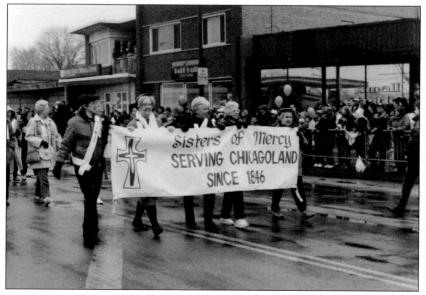

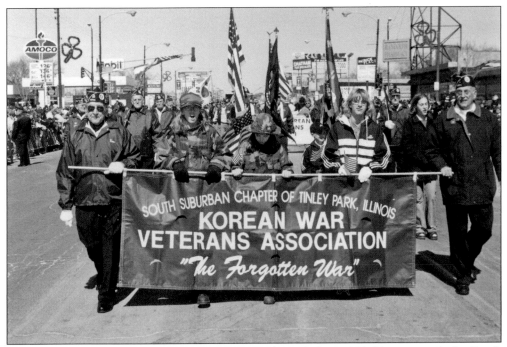

Veterans of the Korean War were honored as grand marshals in 1999. Veterans with the South Suburban Chapter of Tinley Park marched proudly with family and friends during the parade. Below, parade coordinator Jim Sheridan, Jack O'Connor, Bill Letz, and Bill Gainer stand by as a veteran cuts the parade ribbon, signaling the start of the parade. Veteran Bill Minnich of Tinley Park, who served in the army's 2nd Infantry Division in the early 1950s, told the *Chicago Sun-Times* that having the Korean War veterans serve as the grand marshals was a great recognition of a forgotten war. (Courtesy of the South Side Irish Parade Committee.)

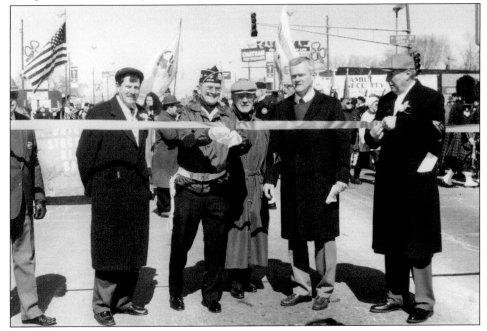

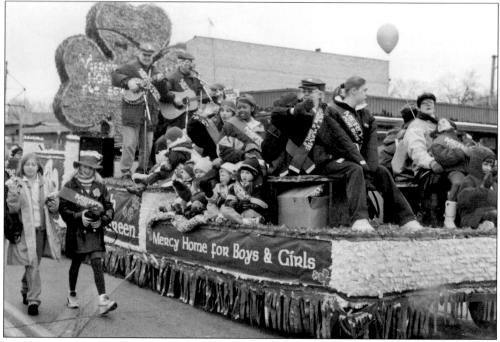

In 1998, the Mercy Home for Boys and Girls was honored as grand marshal. Founded in 1887, the privately funded organization, located in Chicago, provides at-risk 11- to 21-year-olds with a home, food, clothing, education, and medical assistance. Fr. Jim Close presided at Mercy Home for 33 years and attended the parade with Fr. Scott Donahue, who became president of Mercy Home in 2006. The two were joined by the mayor of Galway, Ireland—Michael Leahy—at the start of the parade, and all three helped to cut the ribbon. The organization currently helps more than 22,000 children and adolescents from dysfunctional and chaotic domestic situations. (Photograph by Don Bowman, courtesy of the South Side Irish Parade Committee.)

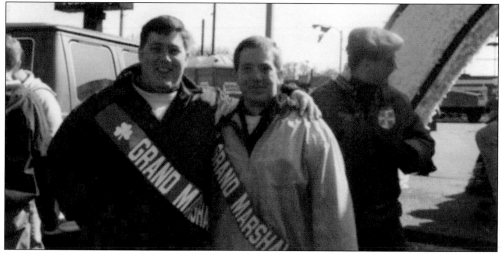

In 1993, original Wee Folks Kevin and Pat Coakley stand together in front of their float to mark the parade's 15th year. When the parade first began, all of the 17 children were under the age of 10. By 1993, some were in high school, college, graduate school, or employed full time in civilian or military careers. (Courtesy of Marianne Coakley.)

A large patriotic crowd came out to cheer on the parade despite the dreary weather on March 17, 2002. The world was a different place after the September 11, 2001, attacks on the World Trade Center and the Pentagon. To honor the thousands of men and women who lost their lives, the parade committee decided to have a marching unit of 50 New York police officers, military veterans, and Chicago police and firefighters serve as grand marshals. Families of St. Cajetan parish led the parade, which was also celebrating its 75th anniversary that year. (Photographs courtesy of the South Side Irish Parade Committee.)

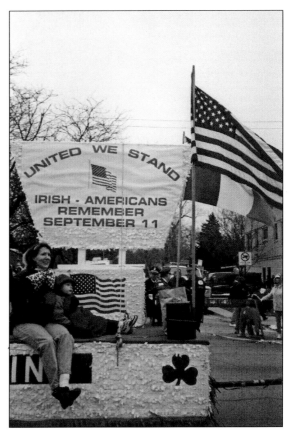

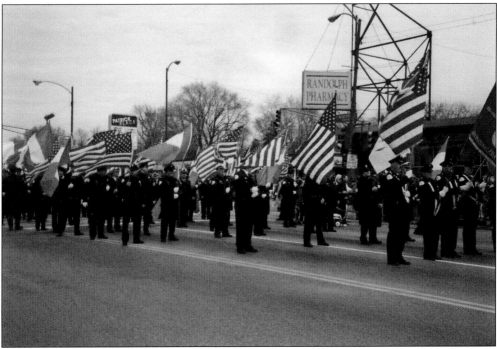

43

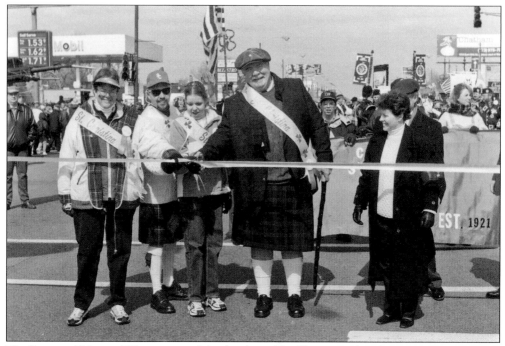

The Reverend Martin O'Donovan and the families of St. Christina Church in Mount Greenwood were honored as grand marshals in 2001. Parade spokeswoman Mary Beth Sheehan, top, far right, smiles as parishioners of the St. Christina Church help O'Donovan cut the ribbon, signaling the start of the parade. O'Donovan was the pastor of that church, which was celebrating its 75th anniversary, and served as the parade chaplain for many years. More than 200 entries participated in this parade, which brought out approximately 300,000 spectators, thanks to a bright and sunny day. (Photographs courtesy of the South Side Irish Parade Committee.)

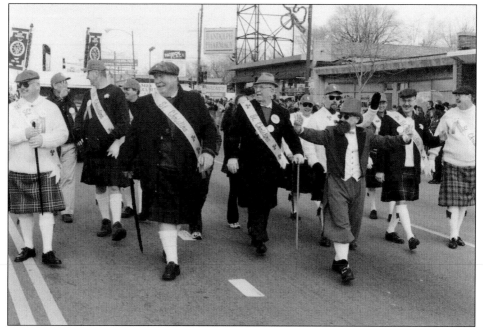

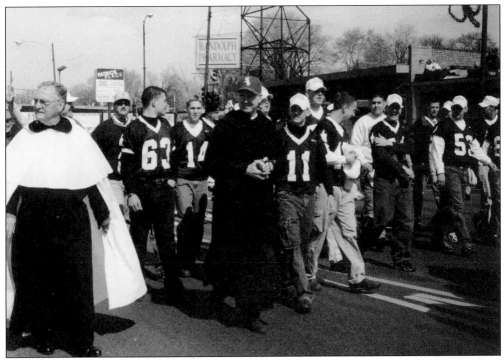

In 2000, Mount Carmel High School and the Carmelites served as parade grand marshals. The all-male, private, college-prep Catholic high school, located in Chicago, is run by the Carmelite order of priests and brothers. Known for rigorous academics and strong athletic teams, Mount Carmel also boasts local alums including actor and playwright Mike Houlihan, Cook County sheriff Tom Dart, and novelist James T. Farrell, author of the *Studs Lonigan* trilogy. Fr. Mike O'Keefe, pictured above, leads members of the football teams of Mount Carmel, Joliet Catholic, and Carmel of Mundelein (all Carmelite high schools) down the parade route with Fr. Leo McCarthy. At right, Fr. Dave Dillion dons a green derby hat and walking stick as he marches with the Carmelites. (Photographs by Don Bowman, Courtesy of the South Side Irish Parade Committee.)

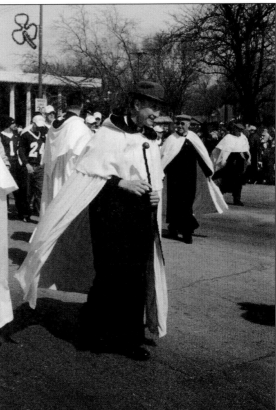

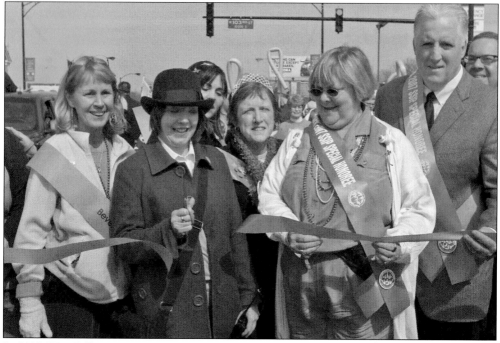

In 2007, Wee Folk Annie Coakley cuts the ribbon at the start of the parade while surrounded by members of the Beverly Breast Cancer Walk and the Beverly Area Planning Association. The Beverly Breast Cancer Walk was honored as grand marshal of the parade that year. This organization has similar roots as the parade, in that it began as a small walk among friends and family on Mother's Day. In 2009, the Beverly Breast Cancer Walk celebrated its 10th anniversary and is now one of the largest walks on the South Side. The organization has helped to raise nearly $1 million for the Little Company of Mary Hospital's cancer center. (Photographs by Art Morgan, courtesy of the South Side Irish Parade Committee.)

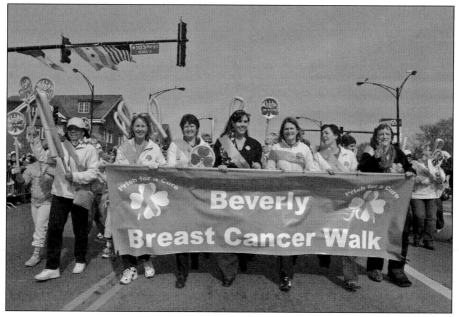

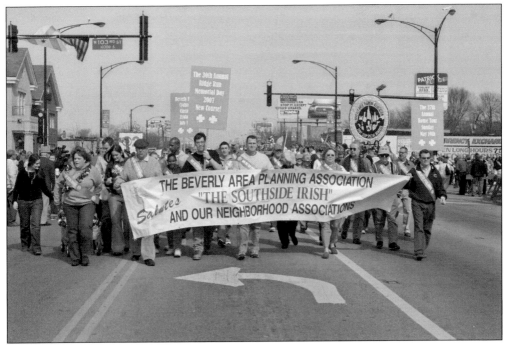

In 2004, the parade committee added a "special honoree" to the lineup, which allowed two organizations to be highlighted and honored. The first special honoree title went to St. Rita of Cascia High School, as it was celebrating 100 years on the South Side. In 2007, the Beverly Area Planning Association, pictured above, was named special honoree. The not-for-profit, community-based organization is comprised of more than a dozen civic and business groups dedicated to serving the Beverly Hills and Morgan Park neighborhoods. Below, the St. Baldrick's Fox Chicago Schools Challenge was named special honoree in 2009. The St. Baldrick's Foundation is known for the thousands of people who volunteer to shave their heads in solidarity with children with cancer, while working to raise donations for research. (Photographs by Art Morgan, courtesy of the South Side Irish Parade Committee.)

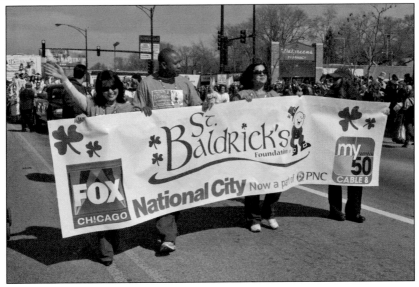

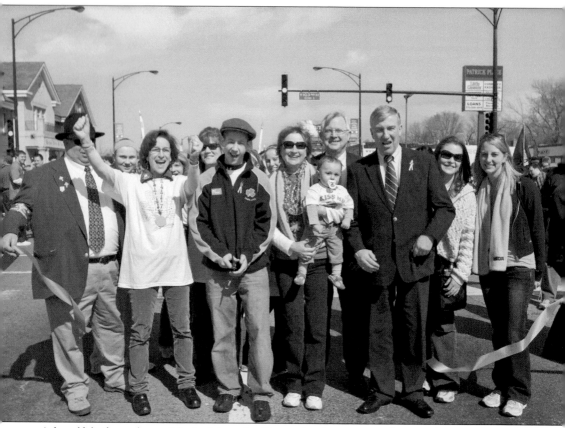

A handful of members with the Muscular Dystrophy Association cheer as they cut the parade ribbon in 2009. The organization was named grand marshal in the parade's final year. Muscular dystrophy is a group of progressive disorders caused by a defect in one or more genes that control muscle function. The *Southtown Star* reported that the nonprofit association helps approximately 3,000 children and adults in Chicago and its suburbs every year. (Photograph by Art Morgan, courtesy of the South Side Irish Parade Committee.)

Four

THE MARCHIN' OF THE BANDS

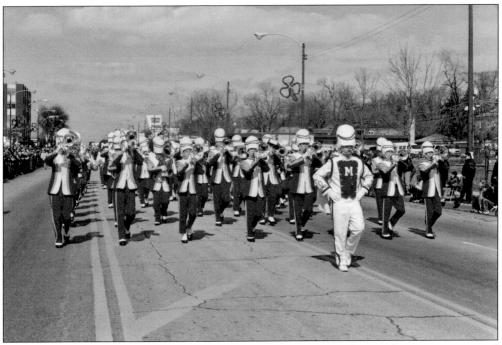

Once the parade began to march down Western Avenue in 1981, the parade committee turned to local high schools and asked if the school marching bands would join the lineup. The award-winning Marist High School Marching Band was one of the first bands to sign up, and has wowed parade crowds for years. (Photograph taken by Don Bowman, courtesy of the South Side Irish Parade Committee.)

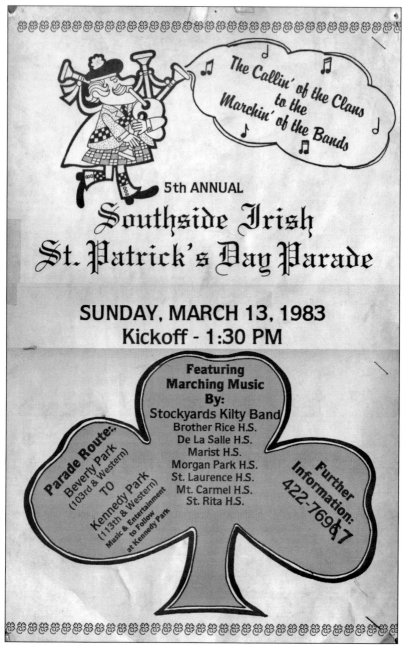

This poster for the fifth annual South Side Irish Parade in 1983 shows a bagpiper playing a tune to the year's theme, "The Callin' of the Clans to the Marchin' of the Bands." In five years, the parade had ballooned from a small group walking around the block, to thousands marching down Western Avenue. The poster had a famous error on it, as the phone number listed for "Further Information" was incorrect. Rather than calls to the parade committee, people were calling an elderly couple who had no connection to the event, Marianne Coakley said. The couple received tons of calls about the big day, and when the mistake was realized, the parade committee quickly apologized. They tried to fix the posters by hand and sent the couple a gift certificate to a local restaurant. (Courtesy of Marianne Coakley.)

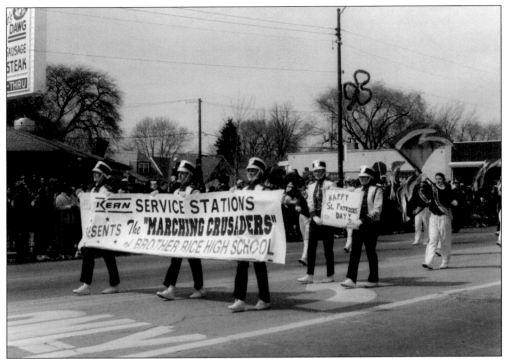

The "Marching Crusaders" of Brother Rice High School play to the more than 200,000 spectators on Western Avenue in 1997. Founded by the Christian Brothers of Ireland, the all-male Catholic high school has a unique aspect to its band—students from the all-female Mother McAuley High School, located less than half a mile away, play with it. Brother Rice and Mother McAuley each welcomed their first freshmen classes in 1956, albeit separately. Many of the students at both schools were, and still are, from local neighborhoods, including Beverly, Oak Lawn, and Evergreen Park. (Photographs taken by Don Bowman, courtesy of the South Side Irish Parade Committee.)

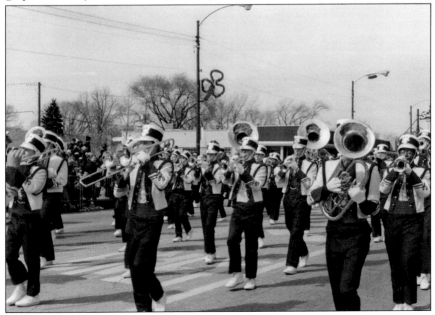

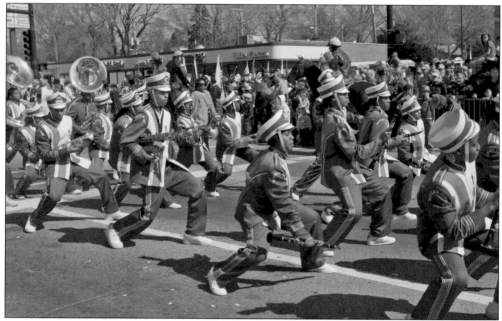

The Morgan Park High School Marching Band entertains the crowd of approximately 300,000 at the 2009 parade. Located at 111th Street and Vincennes Avenue, the Chicago Public High School opened its doors to 283 students in 1916. The marching band has been a part of the parade since the early 1980s. (Photograph by Art Morgan, courtesy of the South Side Irish Parade Committee.)

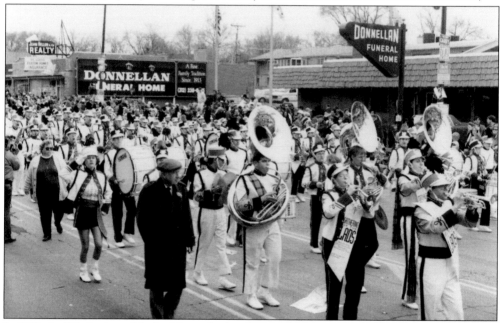

In 1994, the "Gathering of the Lads" marched in the parade. The group was comprised of more than 800 graduates of Christian Brothers schools including St. Leo, Brother Rice, and St. Laurence High Schools, according to the *Beverly Review*. They gathered together to mark the 150th anniversary of the death of the Blessed Edmund Ignatius Rice, founder of the Christian Brothers of Ireland. (Photograph Don Bowman, courtesy of the South Side Irish Parade Committee.)

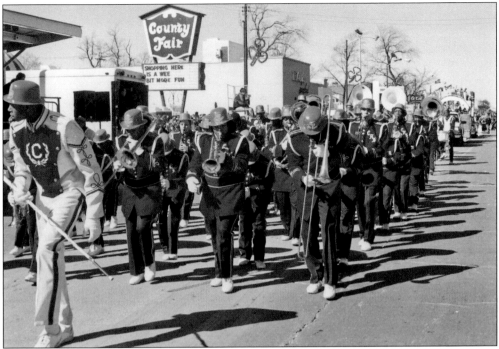

On a cool, but sunny, parade day in 1999, the Curie High School Marching Band excited the crowd with a handful of songs. The Chicago public high school offers an international baccalaureate program to the more than 3,000 students enrolled at the school. (Photograph courtesy of the South Side Irish Parade Committee.)

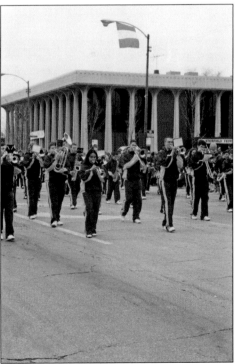

Although there was an overcast sky and intermittent rain, a large crowd still came out and saw the Carmel High School Marching Band play at the 2002 parade. Carmel Catholic High School is located in Mundelein and came together in 1988 when the Carmel High School for Boys and the Carmel High School for Girls merged. The school now houses more than 1,400 students. (Courtesy of the South Side Irish Parade Committee.)

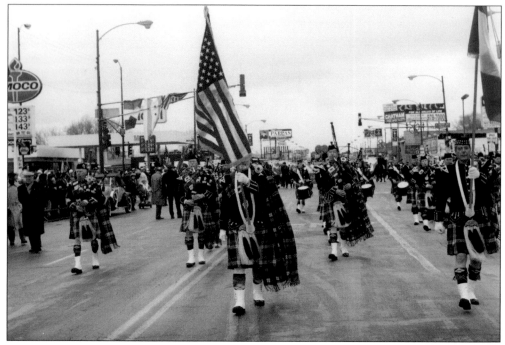

The Chicago Stock Yard Kilty Band has been part of the South Side Irish Parade since 1981. Formed by brothers Robert and James Sim, the Stock Yard Kilty Band is one of the oldest continuous pipe bands in the country. In 1921, Robert Sim formed the British Legion Pipe Band. By 1925, the Chicago Stock Yard American Legion Post No. 333 was looking for a musical unit, and the two became affiliated. By 1926, Sim changed the band's name to the Chicago Stock Yard Kilty Band. In 1931, some members broke off and formed a new band, the Chicago Highlanders, a pipe band that is still around today. (Photographs by Don Bowman, courtesy of the South Side Irish Parade Committee.)

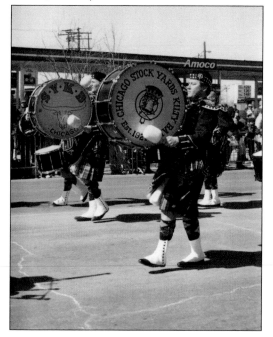

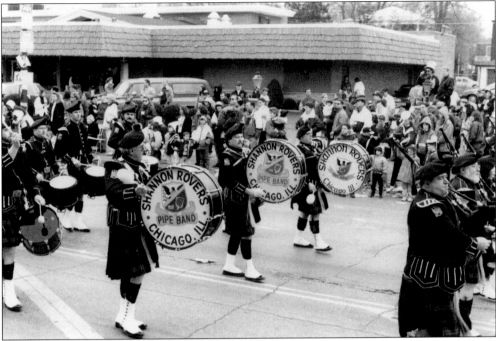

In 1994, the Shannon Rovers Irish Bagpipe Band played Irish tunes for the crowd. This pipe band is one of the most famous in Chicago and has played in the parade for years. Created in 1926 as the Shannon Rovers Club, the band is made up of more than 70 pipers, drummers, and color guard. (Photograph by Don Bowman, courtesy of the South Side Irish Parade Committee.)

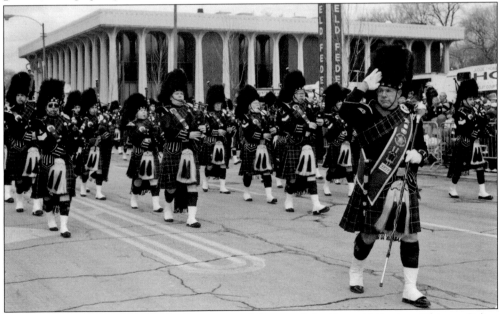

In 1998, the drum major with the Bagpipes and Drums of the Emerald Society, Chicago Police Department, salutes the crowd at the South Side Irish Parade. The well-known pipe and drum band was formed in 1982 and consists of active and retired state, county, City of Chicago, and suburban officers. (Photograph by Don Bowman, courtesy of the South Side Irish Parade Committee.)

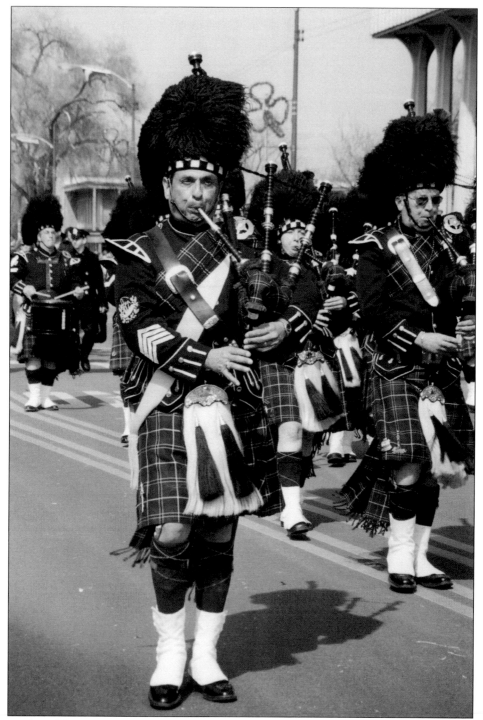

A member of the Bagpipes and Drums of the Emerald Society plays for the crowd in the 2003 parade. The band has played at the South Side Irish Parade for years, entertaining crowds with a handful of songs. It was created in 1982 with the help of former Chicago mayor Jane Byrne and former Emerald Society president Dan Burke. (Courtesy of the South Side Irish Parade Committee.)

Five

FLOATS, COSTUMES, AND DANCERS

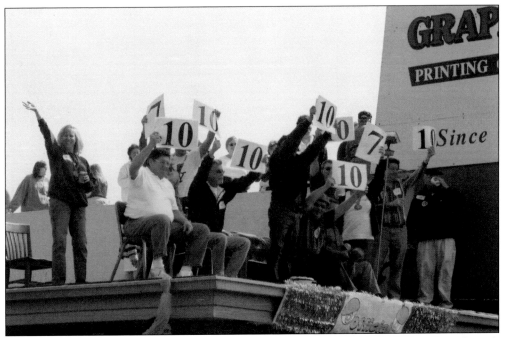

There were numerous floats and costumes in the South Side Irish Parade. This group of South Side residents wouldn't let any parade entrée go unnoticed. Sitting on the roof of Graphic Arts at 105th and Western Avenue, the group held up scorecards as each float passed. The group of friends became a fun staple of the parade. In 1992, when several presidential candidates came to the parade, roofs along the parade route had to be swept for security reasons. (Courtesy of M. Terry Donley.)

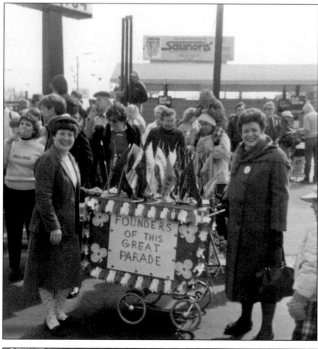

In 1986, Marianne Coakley, left, and Mary Hendry, right, smile as they stand next to the parade's first float. The float was a baby buggy with a box on top, covered in green construction paper and holding the 26 county flags of Ireland. Marianne Coakley has pushed the buggy in every parade for more than 30 years. (Courtesy of Mary Hendry.)

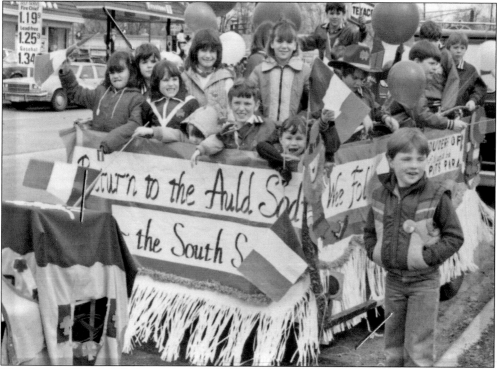

The theme of the parade in 1982 was "Return to the Auld Sod . . . the South Sod," a call to return to Ireland, or more locally, the South Side. Although the baby buggy is the official float of the Wee Folks, in 1982, the kids had a float they could ride on down Western Avenue, which was covered in Irish flags and balloons. (Courtesy of Marianne Coakley.)

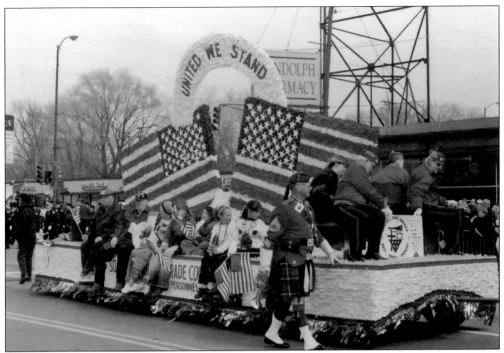

Patriotism was celebrated as much, if not more so, than being Irish in the 2002 parade. Only six months had passed since the September 11, 2001, attacks, and many people all over the country were still reeling from the shock. Floats were covered with American flags, highlighting patriotism as well as Irish heritage. (Courtesy of the South Side Irish Parade Committee.)

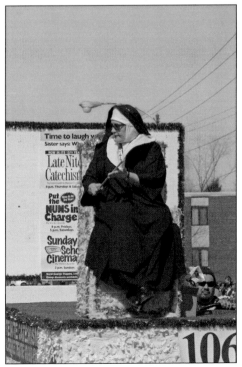

Sister from *Late Nite Catechism* pulls out her ruler, telling the parade crowd to behave themselves or else! The comedic play was created by Vicki Quade and Maripat Donovan who attended Catholic grammar and high school on the South Side. The hit play opened in Chicago in 1993 and has been shown all over the country. (Photograph by Art Morgan, courtesy of the South Side Irish Parade.)

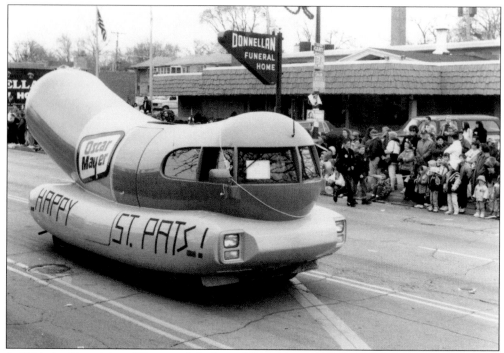

In 1994, the Oscar Meyer Wienermobile drove down Western Avenue, wishing everyone a "Happy St. Pats!" The automobile, shaped like a hot dog in a bun, was created in 1936 and was driven around Chicago to promote Oscar Meyer's "German Style Wieners." Southwest Airlines flew into town to join in on the parade in 1995. A mini-airplane in the clouds was recreated, and passengers waved from their windows as they flew down Western Avenue. Southwest Airlines has been operating out of Midway Airport on the southwest side for years. (Photographs by Don Bowman, courtesy of the South Side Irish Parade.)

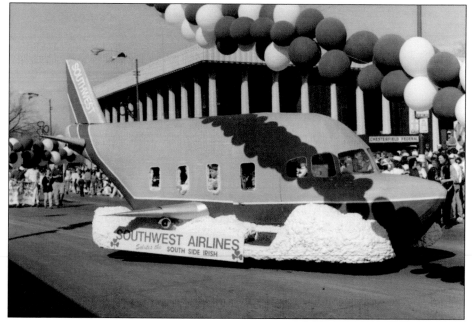

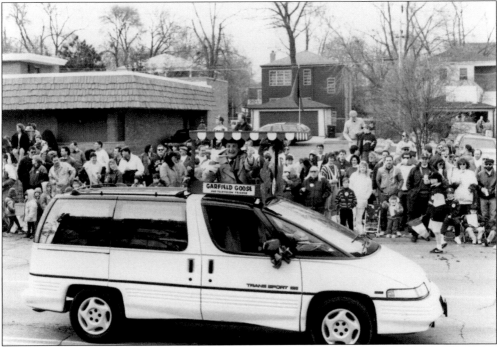

Chicago's very own Garfield Goose made several appearances at the parade over the years, including here in 1994. "Garfield Goose and Friends" was a children's television show produced by Chicago's WGN-TV, and aired from 1955 to 1976 with host Frazier Thomas. (Photograph by Don Bowman, courtesy of the South Side Irish Parade.)

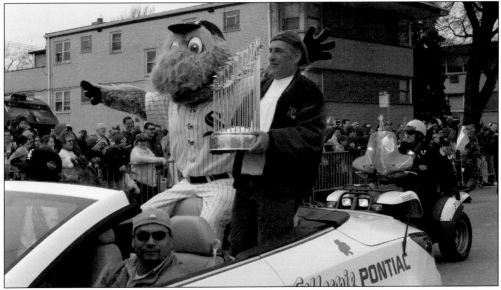

The crowd went wild in 2006, when a car carrying the White Sox World Series trophy drove down Western Avenue. The team is the pride and joy of many of the South Side Irish. The *Chicago Sun-Times* reported that many grown men morphed into little boys when they realized White Sox legend Minnie Minoso was riding in the car with the trophy. In 2005, the White Sox swept the Houston Astros 4–0 to win the title. (Courtesy of the South Side Irish Parade Committee.)

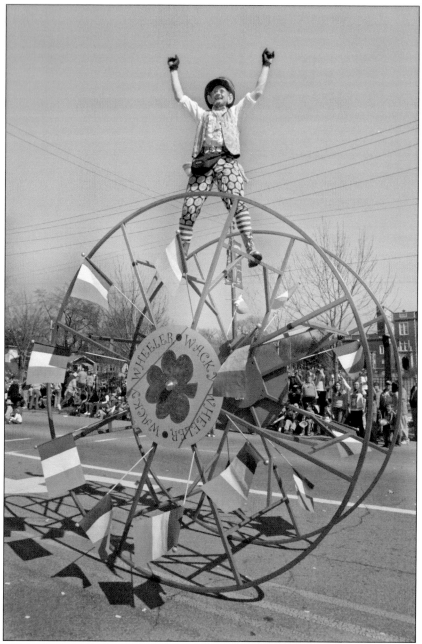

Large floats and acrobatics have always thrilled the crowds at the South Side Irish Parade, but none as much as when the Wacky Wheeler rolled himself and his extra-large wheel in the 2009 parade. Dressed as a leprechaun, the Wacky Wheeler entertained the crowd of approximately 300,000 while climbing the rungs of his wheel. The wacky leprechaun showed off his strength by balancing himself in different positions on the wheel. The crowd erupted into applause and cheers when the Wacky Wheeler finally scaled to the top of his wheel and balanced himself with only his feet. His arms shot up into the air and with a smile, he wished everyone a "Happy St. Patrick's Day!" before easily rolling down with the wheel to the street. (Photograph by Art Morgan; courtesy of the South Side Irish Parade Committee.)

Another crowd favorite came to the parade in 2003, when a monster-sized Jewel-Osco shopping cart drove down Western Avenue. The float was operated by a large motor under the cart, but left many scratching their heads, wondering how anyone could get up high enough to sit in it. (Photograph Don Bowman; courtesy of the South Side Irish Parade Committee.)

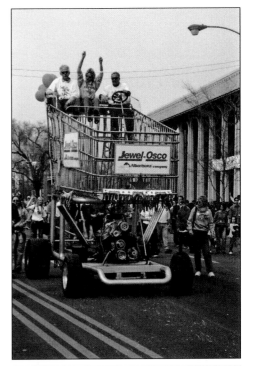

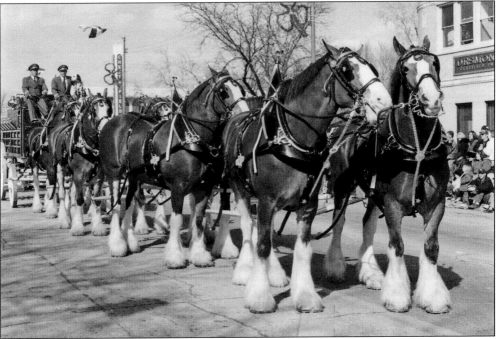

The Anheuser-Busch Budweiser Clydesdales made a handful of appearances in the parade over the years including here in the 2001 parade. The drivers guide their carriage wearing green suits and perched next to them, seated on the front wagon seat, is the dalmatian. These dogs have traveled with the Clydesdale hitch since the 1950s. (Photograph by Don Bowman; courtesy of the South Side Irish Parade Committee.)

The crowds on Western Avenue always got a big kick out of the Medinah Shriners and Clowns. The two groups are branches of the Chicago Shriners Hospital for Children, which provides pediatric specialty care for kids with burns, spinal cord injuries, and cleft lips and palates. The Medinah Genies, above, a unit of the Medinah Shriners of Addison, delight the 2006 parade crowd. The group was formed in 1968 and costumed members drive around on motorized flying carpets. In 2003, the Medinah Shrine Clowns were looking for a little tomfoolery at the parade. Clowns Pee Wee, Jay Jay, and Bingo entertained the crowd with smiles, horns, and a little golf. (Top photograph by Art Morgan; both courtesy of the South Side Irish Parade.)

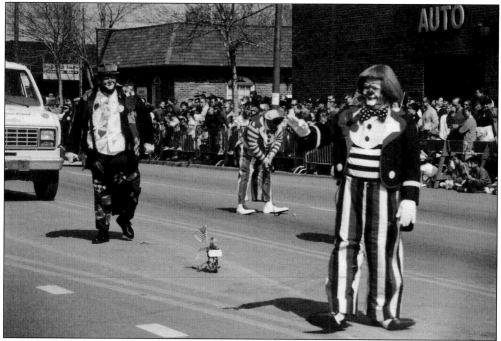

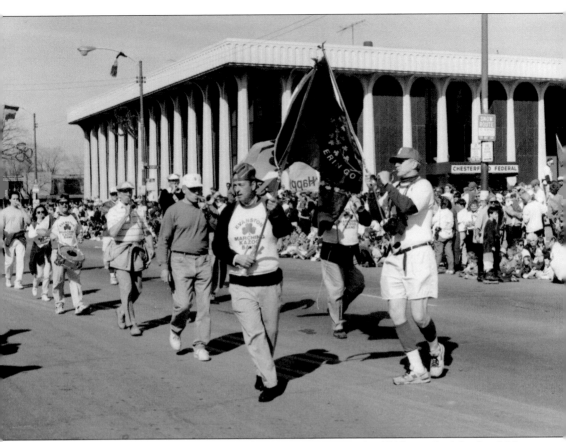

The Evanston Marching Kazoo Band made an appearance in the 1995 parade. Member Mike Roche, left, carries an Irish flag, while members Phil Zera, Bill Debes, and Al Frenzel march with the band. The local marching band specializes in just one instrument—the kazoo. While at the parade, the band marched and played Irish tunes, while their color guard helped wave an Irish flag that read, "Erin Go Bragh." The band likes to toot its own horn, or kazoo, and members have stated that they are extremely talented, with an unmatched level of coordination and body control. They have gone on to say each band member could qualify for an Olympic gymnastic event at a moment's notice. Charter members of the group include Jim Bishop, John Bordes, Bill Debes, Larry Dooley, Tom Leonard, Jay Lyttle, Mike Roche, Art Smith, Dick Stack, and Jim Trimble. Founded in 1975 by Jack Callahan, the group also stated "we are very good looking and admired by millions." (Photograph by Don Bowman; courtesy of the South Side Irish Parade.)

Da Greens Brothers stop and smile for a photograph at the 2003 parade. They say they are the competition to the Blues Brothers and the official greeters to the world. From left to right are Don Ferone, Jack Dreznes, and Mike Schaller. Dreznes is the owner of Beverly Records, and the group purchased their costumes from the nearby Beverly Costume and Novelty Shop. (Courtesy of the South Side Irish Parade Committee.)

Children were thrilled when Disney's Minnie Mouse waved to them while walking down Western Avenue in the 1994 parade. Many favorite cartoon and childhood charters have also visited the parade, including Batman, the Teenage Mutant Ninja Turtles, Elmo, and Cookie Monster. (Photograph by Don Bowman; courtesy of the South Side Irish Parade Committee.)

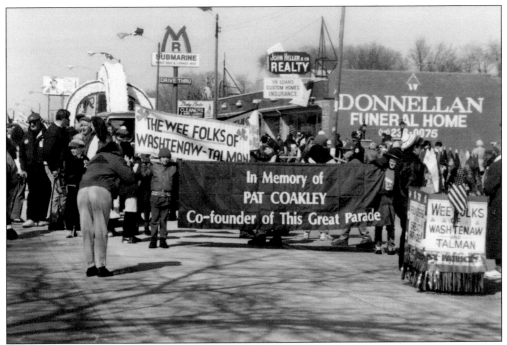

In 1991, the Wee Folks of Washtenaw and Talman honored parade cofounder Pat Coakley by marching with a large banner that read, "In Memory of Pat Coakley, Co-founder of This Great Parade." Coakley died suddenly of a heart attack at the young age of 44, but his spirit has lived on in the parade for many years. (Courtesy of Kathleen Hughes.)

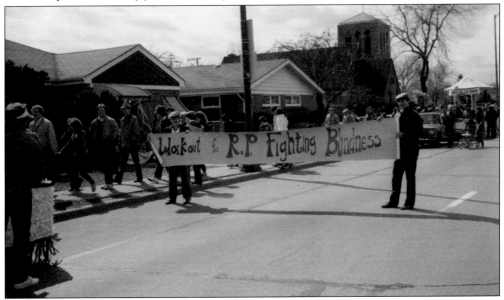

Marchers with the Workout for R. P. Fighting Blindness carry their banner in 1985. "The Workout" Fitness Studio in Morgan Park, owned by St. Cajetan preschool teacher Peggy Evans, always sponsored a float in the early years. It featured her preschoolers and advertised the "aerobathon" to combat retinitis pigmentosa. This was especially important since one of her preschoolers, Colleen Hart, was losing her vision to this sight-stealing disease. (Courtesy of Beth Hart.)

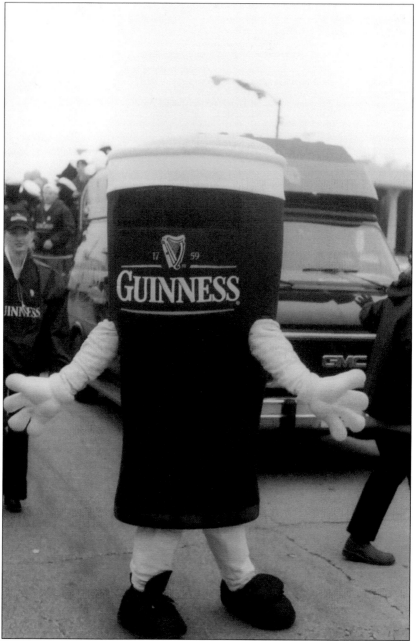

A pint of Guinness never looked as good as it did while marching down Western Avenue in the 2002 parade. The stout of choice among many Irishmen, the perfect pint of Guinness is poured in two parts, according to the company. The drink is first poured into a clean, dry glass at a 45-degree angle and filled only until the glass is three-quarters full. Bartenders then allow the beer to settle before filling it to the top. Guinness is still brewed at the St. James's Gate Brewery in Dublin, Ireland. It was founded in 1759, when Arthur Guinness signed a 9,000-year lease on the property. He purchased the property for £100, about $147 U.S. dollars, with an annual rent of £45, about $66 U.S. dollars. The famous brewing company celebrated its 250th year in 2009. (Courtesy of the South Side Irish Parade Committee.)

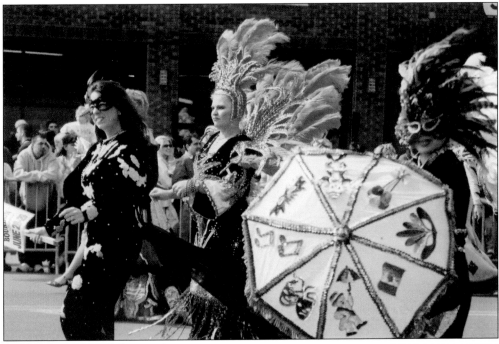

Many groups entered the parade in costumes, as seen in this 2003 photograph, above. Decked out in colorful masks, feathers, and dresses, this group is ready to celebrate Mardi Gras at a moments notice. To the right, the Little People visit the South Side Irish Parade in 1998. Dressed as leprechauns, the male and female street performers bring the spirit of St. Patrick with them as they walk the entire parade route, waving to the crowd, shaking hands, and taking photographs with children and adults. (Top photograph by M. Terry Donley; right photograph by Don Bowman; courtesy of the South Side Irish Parade Committee.)

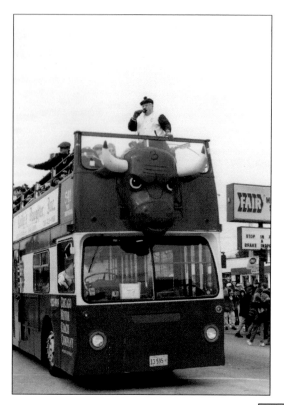

In 1997, a large red bus with the head of the Chicago Bulls on top rode through the parade to cheers. The number three on the bull's forehead represented the basketball team's first "three-peat" for winning three NBA titles in a row from 1991 to 1993. By 1997, the team was already on their way to repeating their three-peat, which they did in 1998. (Courtesy of the South Side Irish Parade Committee.)

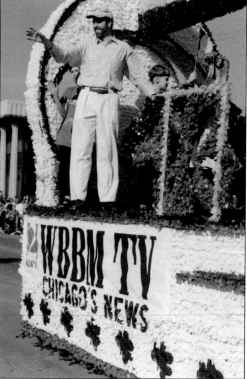

CBS Channel 2 political editor and South Side resident Mike Flannery wave to the crowd from atop the WBBM float. Flannery has been covering Chicago's City Hall, Springfield, and state elections since 1980. (Courtesy of the South Side Irish Parade.)

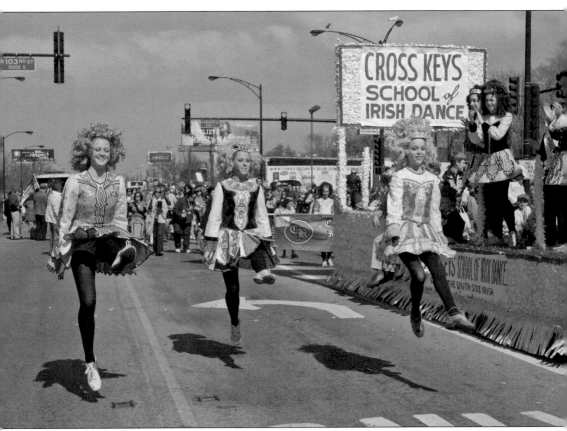

Three dancers with the Cross Keys School of Irish Dance jump high while performing for the parade crowd in 2009. The school is run by director Kathleen O'Carroll, who was born and raised in Chicago, but whose parents hail from Ireland. All Irish dancers wear very ornate dresses embroidered with silk and lace. The dress color indicates what level the dancer has achieved, from beginner to advanced. (Photograph by Art Morgan; courtesy of the South Side Irish Parade Committee.)

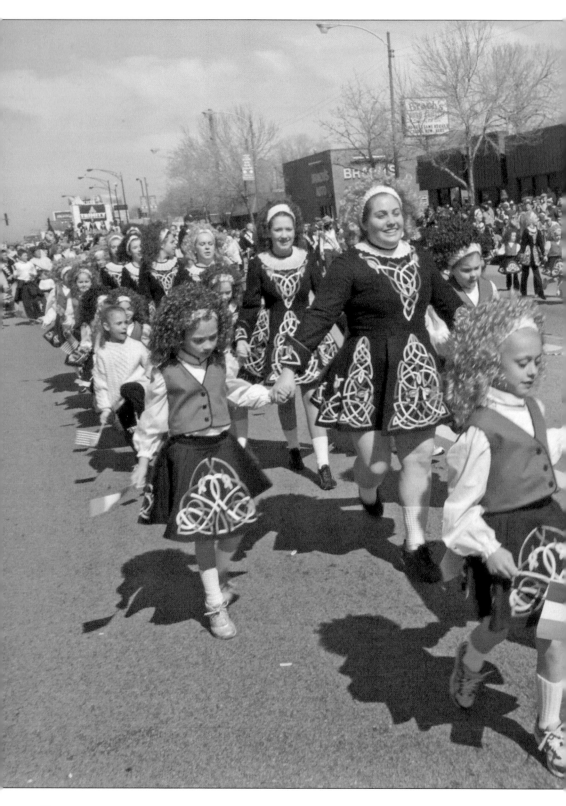

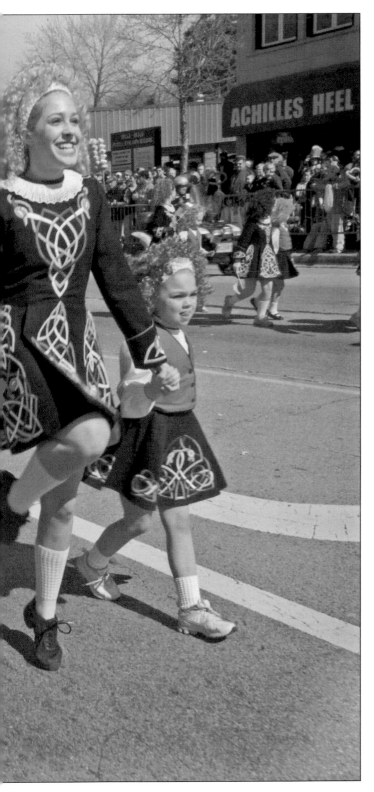

Dancers with Trinity Academy of Irish Dance jig their way down the parade route in 2009. Trinity is one of the most widely recognized dance programs in the country. The academy was formed in 1979 by Mark Howard, and has performed all over Chicago and beyond. (Photography by Jason Brown.)

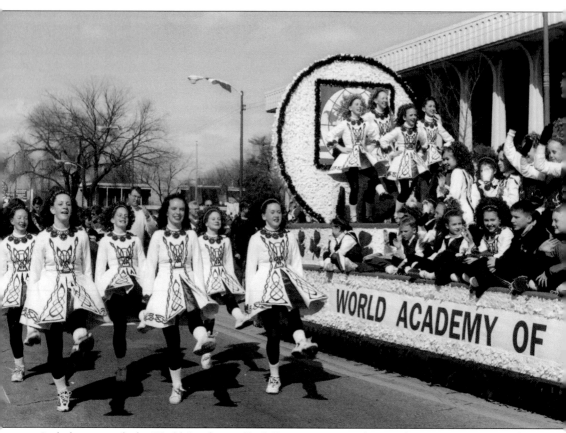

Irish dancers with the World Academy of Irish Dancing jump and point their toes in unison as they dance down the parade route in 2009. The academy is lead by Julie Showalter, an accomplished hall of fame Irish dancer. Dancers are required to keep their arms straight at their sides, while their legs and feet do all the work. The Celtic folk dance has been around for centuries, but it became incredibly popular in the late 1990s when Irish dancer and South Side native Michael Flatley performed in the Irish musical and dance show *Riverdance*. Flatley went on to produce, direct, and choreograph his own show, *Lord of the Dance*. Irish dancers were a highlight of all the South Side Irish parades, as dancers delighted crowds with their intricate footwork. (Photography by Art Morgan, courtesy of the South Side Irish Parade Committee.)

Six

St. Patrick and Leprechauns

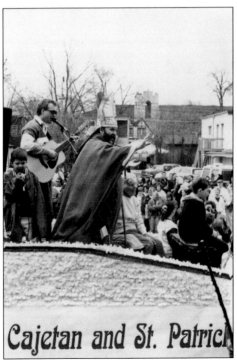

Cajetan and St. Patrick

No St. Patrick's Day Parade would be complete without a St. Patrick. Born near the end of the fourth century, St. Patrick died on March 17, around 460 A.D. The patron saint of Ireland has been celebrated in every South Side Irish Parade since it first began in 1979. Here Fr. Stanley G. Rataj, with St. Cajetan Church, blesses the crowd at the 1994 South Side Irish Parade as parishioner Jim Glennon plays guitar. (Courtesy of South Side Irish Parade Committee.)

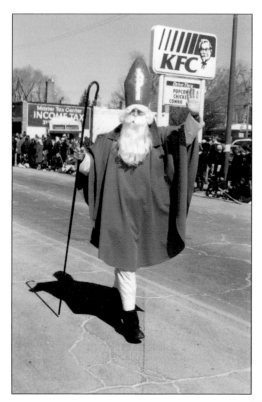

At left, St. Patrick waves to the camera during a sunny parade day in 1999. Below, St. Patrick is joined by Uncle Sam in 2003. The two waved and walked the parade route together. In 432 A.D., St. Patrick came to Ireland to convert the Irish to Christianity while building schools and monasteries along Ireland's north and west coast, according to St. Patrick's autobiographical confession called *Confessio*. St. Patrick is most widely known for driving the snakes out of Ireland. (Courtesy of the South Side Irish Parade Committee.)

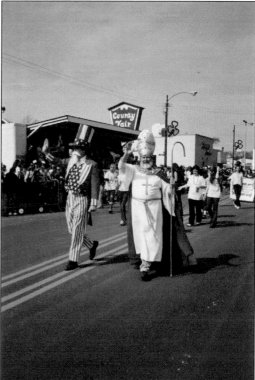

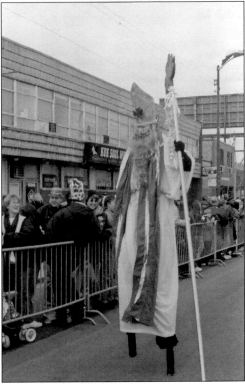

Over the years, St. Patrick has been portrayed in many shapes and sizes in the parade, and by the young and old. In 2002, St. Patrick stood tall—very tall—while on stilts and held an extra-long staff as spectators in the crowd looked up at him. A smaller St. Patrick braved dreary whether as he waved to the crowd in 1996, while being pulled in a small wagon down the parade route. (Courtesy of the South Side Irish Parade Committee.)

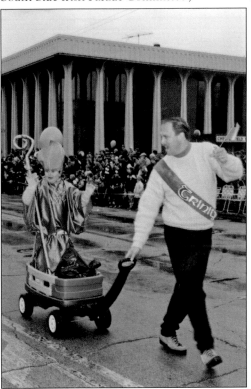

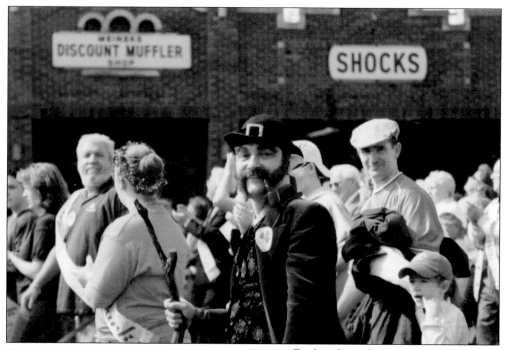

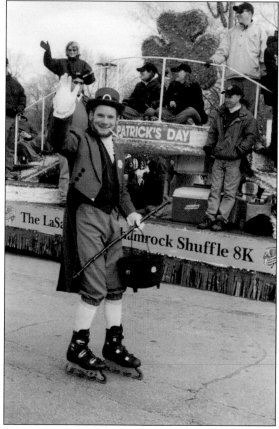

Finding leprechauns at the South Side Irish Parade isn't hard, but sometimes they do slip into the crowd, almost unnoticed, as pictured above. Other leprechauns jump right out on rollerblades and whiz past with a pot of gold, as pictured below. (Courtesy of M. Terry Donley and the South Side Irish Parade Committee.)

Seven

ENGAGEMENTS

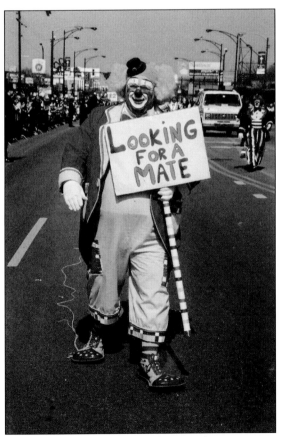

Dressing as a clown was one way to get attention, but another was to pop the question during the South Side Irish Parade. Proposals became somewhat common in the parade as the years went on, and photographs will show each time she said "Yes!" (Courtesy of the South Side Irish Parade Committee.)

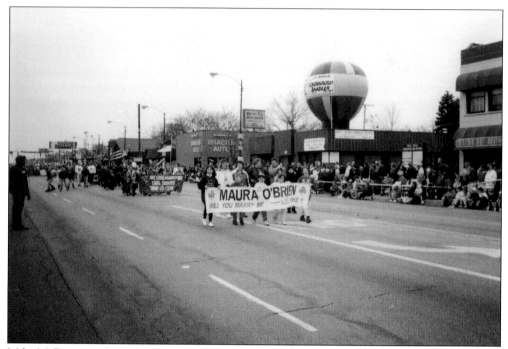

Mike McDermott claims he was the first to propose at the parade in 1994. His proposal to Maura O'Brien became a family affair. He got the idea from his bother, Tom, while the two were in Brussels, Belgium, the week before the parade. While overseas, Mike called Bill Gainer to help coordinate getting the banner in the parade. Mike rallied his nieces and nephews to carry the banner for one block on Western Avenue. Maura and Mike were standing at 104th Street and Western Avenue, just outside the old Fielos Restaurant, when Maura saw the sign. Mike quickly got down on one knee and asked Maura to marry him. She said yes, and it was all caught on videotape thanks to Mike's brother-in-law, Kevin McCarthy. (Courtesy of Mike and Maura McDermott.)

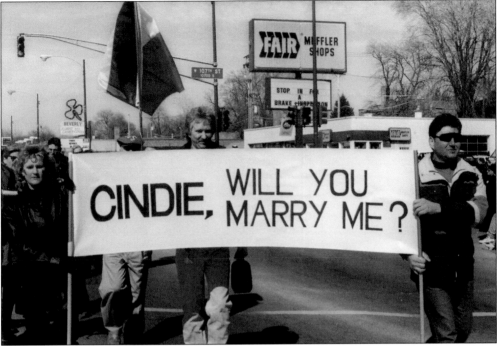

In 1997, all this gentleman needed was a ring and a banner large enough to ask, "Cindie, Will You Marry Me?" Friends, who were in on the plan, held the banner on each side as he marched down Western Avenue to propose. From the looks of the photograph below, Cindie said "Yes!" and the crowd, as well as her fiancée, shouted with joy. (Courtesy of the South Side Irish Parade Committee.)

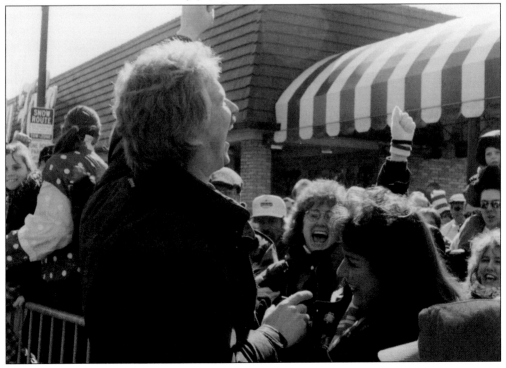

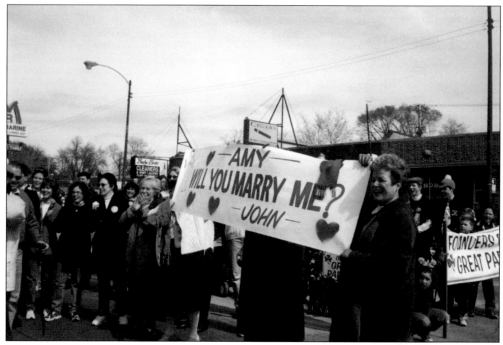

South Side resident Amy Wahl was clearly surprised when her boyfriend, John Scott, asked her to marry him at the 2000 parade. Standing in front of Hector's Upholstery, near the corner of 105th Street and Western Avenue, John wrangled in some special guests to help him with his surprise. Wahl was watching the parade when Marianne Coakley and Mary Hendry came up holding a sign that read, "Amy, Will You Marry Me? John." John quickly pulled out a ring and, while wiping away tears, Amy said "Yes!" (Courtesy of Marianne Coakley.)

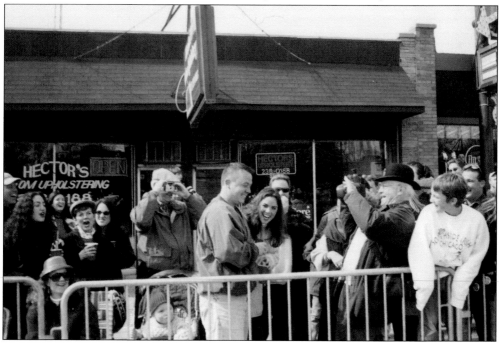

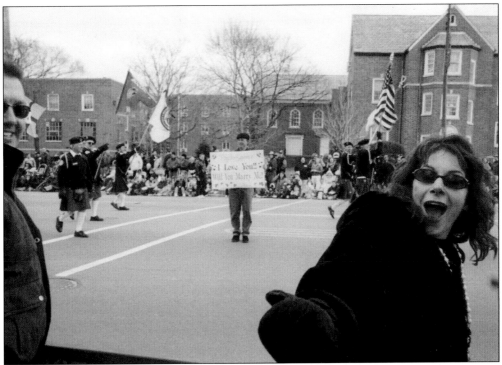

Phyllis Gannon was standing at the northwest corner of Western Avenue at Kennedy Park at the 2004 parade, when she saw something unusual. As bagpipers marched by, her boyfriend, Mike Small appeared with a large sign that read, "Phyllis Gannon, I Love You!! Will You Marry Me?" In the photograph above, the woman in front of Phyllis reveals her shock when she realizes Phyllis is standing behind her. Phyllis said it took her a minute to register what was happening, but soon went under the police barricades, ran to Mike, and with a kiss said "Yes!" (Courtesy of Phyllis Gannon.)

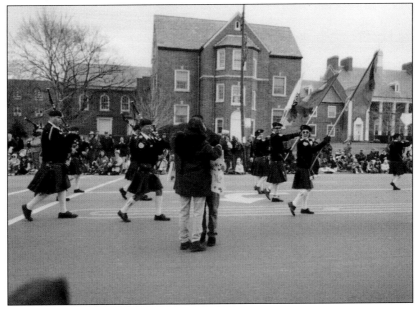

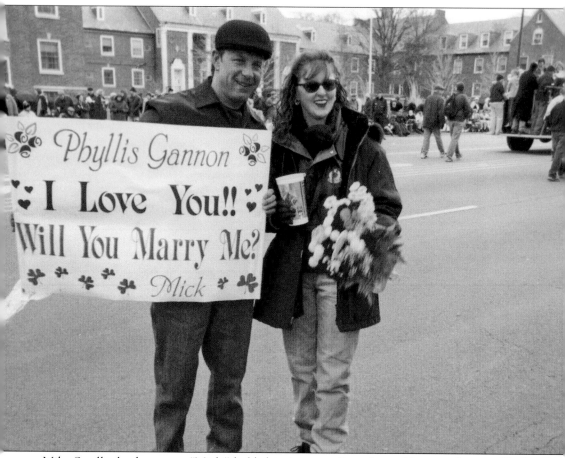

Mike Small, also known as "Mick," holds his sign proudly as he and his new fiancée, Phyllis Gannon, smile for the camera. Phyllis said she was shocked when she saw the sign and flowers, but she loved the proposal. Phyllis said her now-husband decided to propose to her at the parade because the parade meant a lot to each of them. Phyllis had gone to the parade as a child and had attended St. Barnabas and St. Cajetan's Schools. Mike was from Burbank and was living in Tinley Park at the time. The Smalls moved to Frankfort once they got married but plan on moving back to Beverly some day. (Courtesy of Phyllis Gannon.)

Eight

IRISH CLANS AND
PARISHES

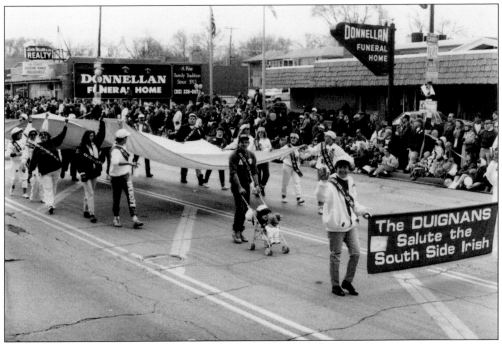

Family and children were at the heart of every South Side Irish Parade, and many families decided to show their pride by marching. Grandparents, parents, children, and grandchildren made banners, wore sweatshirts, and carried signs with their family's surname. After the parade, many families across the South Side held open house parties for family, friends, and strangers they had not yet met. (Courtesy of the South Side Irish Parade Committee.)

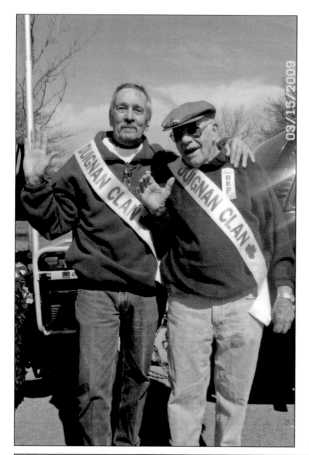

The Duignan family has marched in the South Side Irish Parade for years. This creative clan really gets into the spirit of things. Family members Jimmy and John Duignan, pictured above, proudly wore their family's name on sashes as they waved to the camera. Below, family members Patricia, Jean, Kathy, Sandy, and Kelly Duignan stand next to their family float. Decked out in green and white tissue paper, the family float held loud speakers, the Chicago flag, and a large sign with the family's name on it. The Duignan clan also saluted the 2009 grand marshal, the Muscular Dystrophy Association, by putting the organization's name on their float. Although some South Siders may disagree, the Duignans are in costume and do not really look like leprechauns. (Photographs courtesy of Jeannette Kelly.)

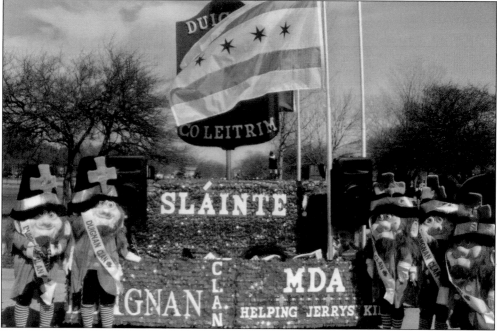

Armed with family sweatshirts and sashes, the Sheahan Clan wished everyone a happy St. Patrick's Day in 1995. This family has marched in the parade for years and includes family members Joe Sheahan, pictured at right; James "Skinny" Sheahan, former executive director of the City of Chicago's office of special events; and Mike Sheahan, former sheriff of Cook County. (Courtesy of the South Side Irish Parade Committee.)

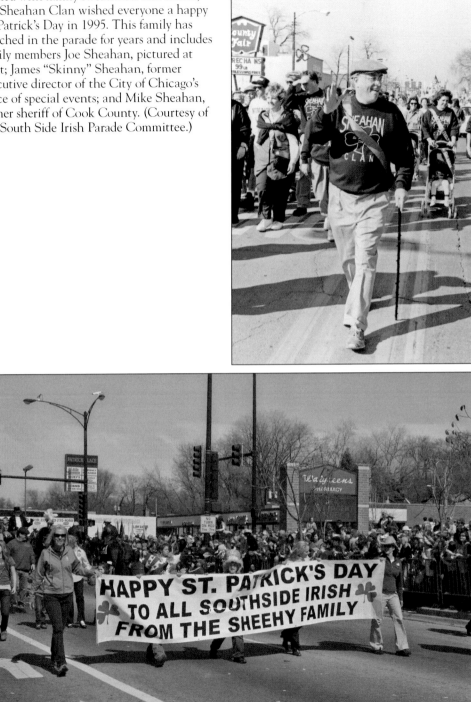

On a sunny parade day in 2009, the Sheehy family wished all of the South Side Irish a happy St. Patrick's Day. The family is a part of R. J. Sheehy and Sons Funeral Home, located in Orland Park and Burbank. (Photograph by Art Morgan; courtesy of the South Side Irish Parade Committee.)

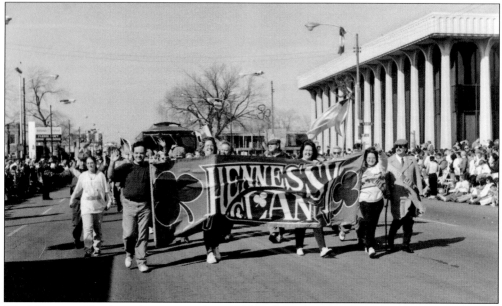

The Hennessy Clan braved strong winds in 1995 to show their family pride. Capt. Bill Hennessy was instrumental in the 79th Street Southtown St. Patrick's Day Parade that marched from 1953 to 1960. (Photograph by Don Bowman; courtesy of the South Side Irish Parade Committee.)

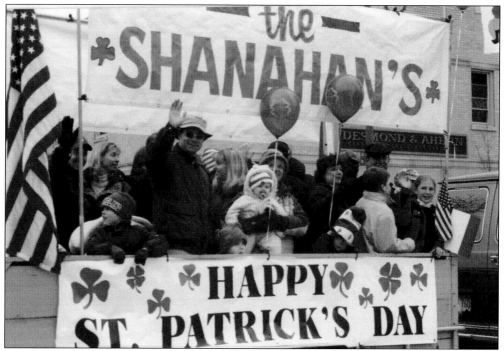

The Shanahan Family came out to salute the South Side Irish Parade in 2002, despite the dreary and cold weather. Covering their float in American flags and green balloons, the family piled a dozen members into their float and rode down Western Avenue. (Courtesy of the South Side Irish Parade Committee.)

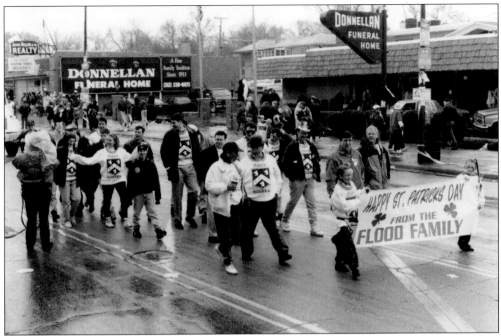

The rain could not stop the Flood family from marching in the parade of 1994. A television camera is covered in plastic to help keep the rain off its lens as the cameraman captures the family walking down the parade route wearing their family crest sweatshirts. (Courtesy of the South Side Irish Parade Committee.)

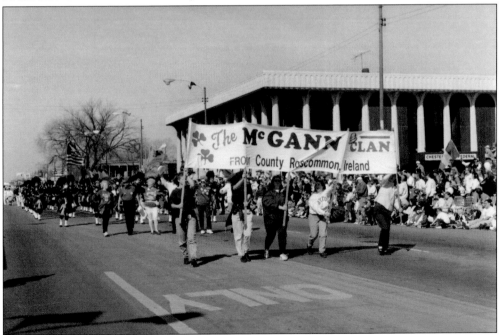

The McGann clan raised their family banner high and marched with pride on a sunny parade day in 1995. The family hails from County Roscommon, one of the largest counties in Ireland. (Photograph by Don Bowman; courtesy of the South Side Irish Parade Committee.)

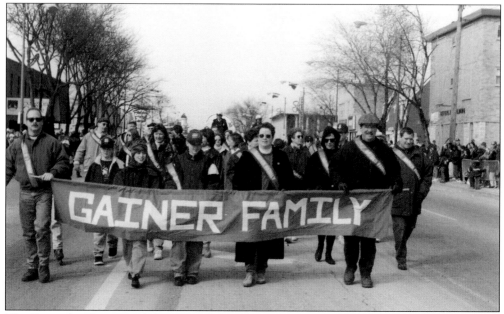

The Gainer family, pictured above in 1997, has marched in the South Side Irish Parade for several years. That year, the parade saw one of its largest crowds, as nearly 200,000 spectators came out to celebrate St. Patrick's Day on the South Side. Family patriarch Bill Gainer has been involved in the parade since the early 1980s. He is a longtime South Sider, a graduate of Mount Carmel High School and committee cochair of the Galway, Ireland, Sister Cities Program in Chicago. (Courtesy of the South Side Irish Parade Committee.)

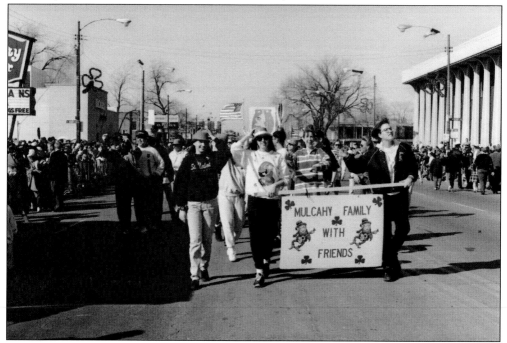

In 1995, the Mulcahy family had to hold on to their green derby hats as the wind hit them while walking down Western Avenue. (Courtesy of the South Side Irish Parade Committee.)

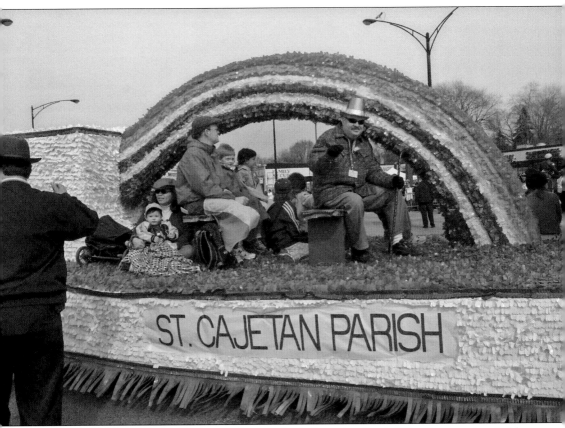

When two people in Chicago discover they are both from the South Side, the next inevitable question is, "What parish are you from?" Parishes helped residents identify where in the neighborhood a person lived. When the parade began in 1979 on the streets of Washtenaw and Talman, it took place within St. Cajetan's Parish. The Catholic Church quickly became synonymous with the parade, thanks in part to a special parade mass held at the church, prior to the parade. The tradition turned into the unofficial motto of the parade: "Pray, Parade, Party." Rev. Martin O'Donovan was the pastor of St. Cajetan's and said mass before the parade for many years. Sr. Sean Morley was the principal of St. Cajetan's School and gave students and staff the day off on the Monday after the parade. In 2002, the families of St. Cajetan's Parish were honored as grand marshals of the parade. (Above photograph by Art Morgan; photographs courtesy of the South Side Irish Parade Committee.)

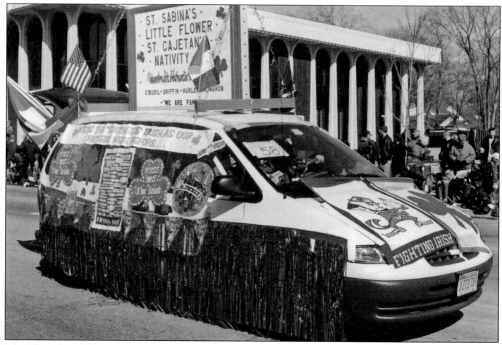

This float from the 2001 parade was created by the families of St. Sabina, Little Flower, St. Cajetan, and Nativity Parishes. The van glistened in green as shamrocks, Irish flags, and the first line of the South Side Irish chorus completed the look. (Courtesy of the South Side Irish Parade Committee.)

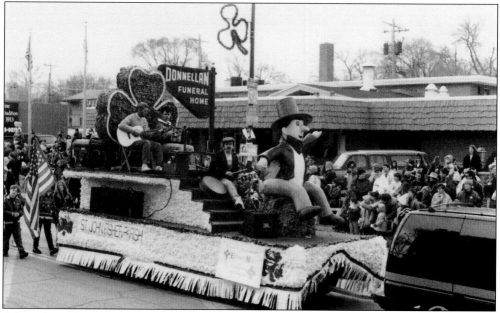

A large leprechaun sits perched on top of the St. John Fisher Parish float, while singers sing some Irish tunes in 1994. Many elementary students from St. John Fisher School annually attended the parade. In the beginning, Fr. Tom Purtell, pastor, and Sr. Jean McGrath, principal, gave students the day off after the parade, as did many of the local parish schools. (Photograph by Don Bowman; courtesy of the South Side Irish Parade Committee.)

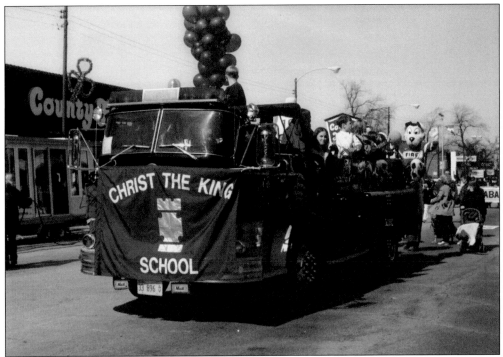

Parishioners and students with Christ the King Church and School ride on a large fire engine in the 2000 parade. The parish is home to many South Siders, including the Houlihan family. Margaret Houlihan Smith, Kathleen Houlihan, and Marty Houlihan all attended Christ the King School, as did their notorious uncle, Mike Houlihan, who has written about his shenanigans while attending the school in his book *Hooliganism*. (Courtesy of the South Side Irish Parade Committee.)

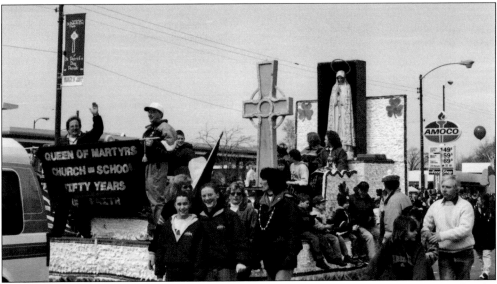

Queen of Martyrs Church and School celebrated "Fifty Years of Faith" during the 2002 parade. The elementary school is located in Mount Greenwood and works to teach children to embrace the values and traditions of the Catholic faith, along with the pursuit of academic excellence, according to the school's mission statement. (Courtesy of the South Side Irish Parade Committee.)

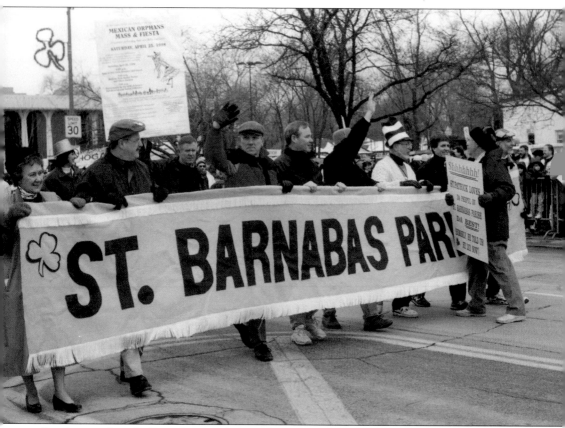

Parishioners from St. Barnabas Parish show their parish pride while marching with a large banner during the 1998 parade. One parishioner holds a sign that reads "Shhh! St. Patrick Loves Da people of St. Barnabas Parish Da Best! (Himself, He Told Us! He Did Now!)" (Courtesy of the South Side Irish Parade Committee.)

Nine

POLITICIANS IN THE BACK

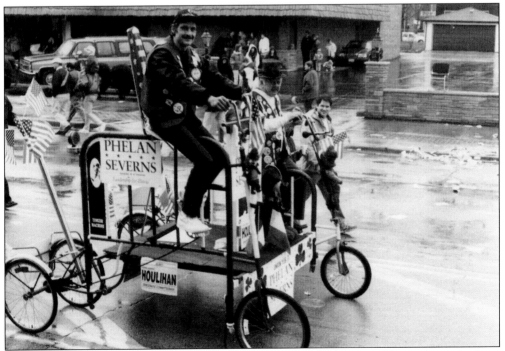

It was quickly decided in the early years of the parade that politicians would never be in the front of the line of march. They were relegated to the center or back, because organizers did not want the focus of the parade to be on the politicians. Instead, children, families, and churches were given priority up front. (Courtesy of the South Side Irish Parade.)

03/12/2005

On March 12, 2005, Orland Park native Bridget McLaughlin, who was crowned the St. Patrick's Day Queen for the downtown parade, posed with then U.S. senator Barack Obama before the parade. The following day, both McLaughlin and Obama marched in the South Side Irish Parade. This wasn't Obama's first time marching in the South Side Irish Parade. On March 12, 2000, Obama marched in the parade with current Cook County sheriff Tom Dart. Obama was running for U.S. representative Bobby Rush's seat in the 1st District, and Dart organized the western part of the 19th Ward on Obama's behalf. The morning of that parade, Obama attended mass and breakfast at the home of BAPA executive director Willie Winters. Obama and Dart then stopped over at Jack and Maureen Kelly's home for some Irish soda bread and breakfast casserole before marching in the parade. Obama lost the Democratic primary to Rush, but was elected to the U.S. Senate in 2004. Just four years later, in 2008, he was elected president of the United States. In 2009, Obama recalled his time at the parade fondly, calling the South Side Irish Parade "one of the great events in America." In the past, the president has maintained that "Obama" is an Irish name, and that all he needs is an apostrophe for him to be Barack O'Bama! (Courtesy of Bridget McLaughlin.)

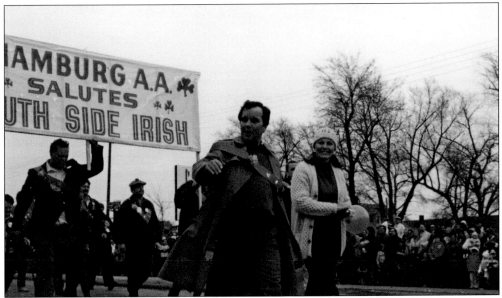

In 1983, then Cook County state's attorney Richard M. Daley and wife, Maggie, marched in the parade. Daley was running for Chicago mayor that year against incumbent Jane Byrne and then U.S. representative Harold Washington, who won. The South Side Irish Parade was a revival of the 79th Street Southtown St. Patrick's Day Parade, which was moved downtown by Daley's father, Richard J. Daley, in 1960. (Courtesy of Mary Hendry.)

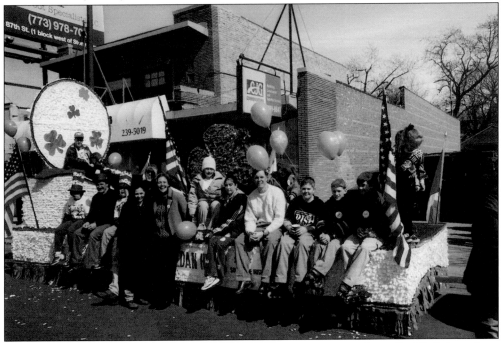

Illinois state comptroller Dan Hynes, in the Irish-knit sweater, joins his wife, Christina, along with family and friends on his parade float in 2000. Hynes was elected to his position in 1998, and made a run against then Illinois state senator Barack Obama for U.S. senate in 2004. Hynes is the son of former Cook County assessor, Tom Hynes. (Courtesy of Dan and Christina Hynes.)

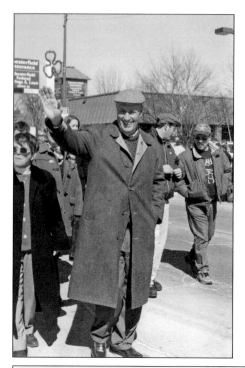

In 1999, Illinois Cook County sheriff Mike Sheahan marched down Western Avenue with his wife, Nancy. The Sheahan family has marched down Western Avenue in the parade for years. After many of the parades, the family would go to Skinny Sheahan's house for a post-parade party. (Courtesy of the South Side Irish Parade Committee.)

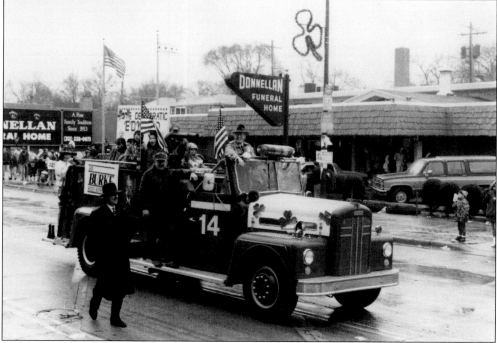

In 1994, 14th Ward alderman Ed Burke wished everyone a "Happy St. Patrick's Day!" over the speaker of his famous fire truck. Burke is the longest-serving Chicago alderman in the city council and has driven family and friends in many of the parades. Burke often invited Bridget, Molly, and Nora Houlihan, along with their mother, Mary Alice, to ride along in the fire truck, an invitation they never passed up. (Courtesy of the South Side Irish Parade Committee.)

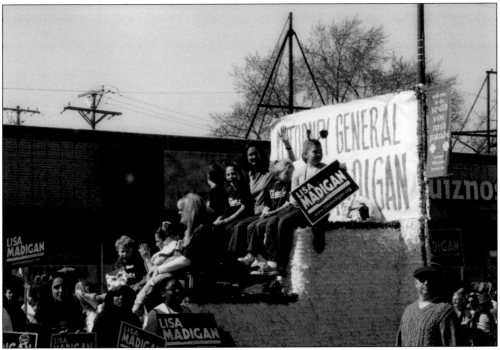

Illinois attorney general Lisa Madigan waves to the crowd lined up down Western Avenue in 2009. Madigan is the daughter of longtime speaker of the Illinois house, Mike Madigan. She became the first female Illinois attorney general in 2003. (Courtesy of M. Terry Donley.)

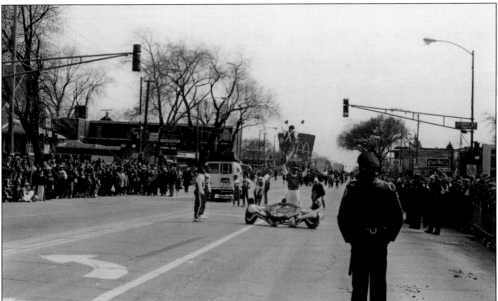

The Jesse White Tumblers thrilled the large parade crowd lined up on Western Avenue in 1997. White, the Illinois secretary of state, began the acrobatic team in 1959, and it has since delighted audiences all over the country. Many of the team members are residents of Chicago's Cabrini Green and Henry Horner housing developments. White was elected to his position with the state in 1998 and was reelected in 2002 and 2006. (Courtesy of the South Side Irish Parade Committee.)

Ireland's Taoiseach Brian Cowen visited the South Side Irish Parade in 2007. As taoiseach, Cowen serves as the country's prime minister. In 2009, Cowen was visiting President Barack Obama when Obama said that he was happy to be meeting with Cowen, but that what Cowen was really missing was the South Side Irish Parade in Chicago. Cowen smiled and said he had been to this great parade. (Courtesy of the South Side Irish Parade Committee.)

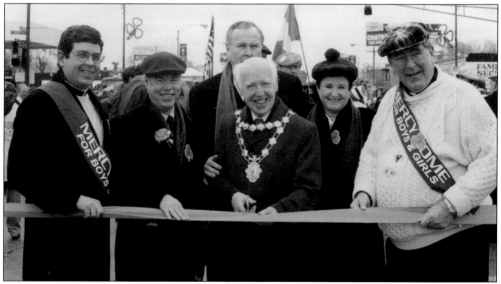

In 1998 Mayor Michael Leahy of Galway, Ireland, pictured center, visited the parade. The medallion around Leahy's neck is worn by members of the annual Ireland trade contingent that come from the island. Leahy served as mayor from 1997 to 1998, as participants in the position are rotated each year. This same year, the Mercy Home for Boys and Girls was named grand marshal of the parade. Helping Leahy cut the parade ribbon are Fr. Scott Donohue, current president and CEO of Mercy Home; parade committee members Mike Hayes and Bill Gainer; 19th Ward alderman Ginger Rugai; and Fr. Jim Close. Father Close presided at Mercy Home for 33 years, mentoring and ministering to thousands of children. He retired in 2006. (Courtesy of the South Side Irish Parade Committee.)

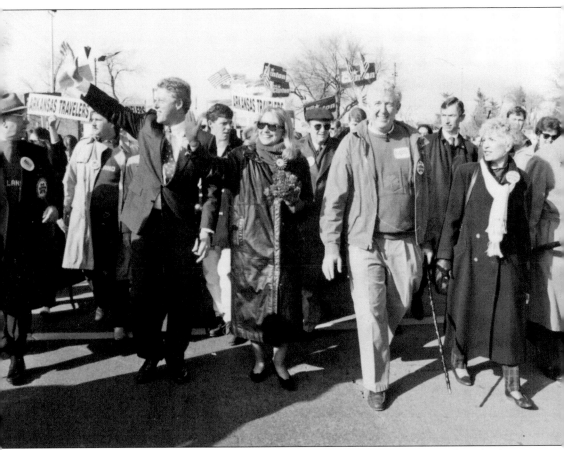

In 1992, then Governor Bill Clinton and his wife, Hillary, marched and waved to the large crowd at the parade. Marching alongside the Clintons is former Cook County assessor Tom Hynes and his wife, Judy. The Hyneses are longtime residents of the South Side. Although the focus of the South Side Irish Parade is meant to be family, the candidates who marched in this parade received the most attention. With the Illinois primary just days away, Clinton, who was governor of Arkansas at the time, was not the only presidential candidate in the parade that year. Candidates Paul Tsongas and Jerry Brown also marched. Clinton secured the Democratic Party nomination and went on to unseat incumbent George H. W. Bush to become president of the United States later that year. Clinton served as president for eight years, and his wife, Hillary, is the current U.S. secretary of state under President Barack Obama. (Photograph by George Todt, Courtesy of Tom Hynes.)

Many families on the South Side, including Mary and Larry Nitsche, held pre- and post-parade parties at their homes. The parties were a chance to get together over food and drinks. For many years, the Nitsches held a post-parade party in the basement of their home. Not only did family and friends stop by, but some well-known politicians did as well. Pictured above are Mary and Larry Nitsche with their daughter, Mary, and Dick Devine, candidate for Cook County state's attorney, in 1996. Devine won and served in that position until 2008. In 1994, Dawn Clark Netsch, Democratic candidate for governor, visited the Nitsche home. Pictured below from left to right are Pat Sullivan, Netsch, Paul Nitsche, Larry Nitsche, and Orland Park police chief Tim McCarthy—who had served as grand marshal of the parade in 1982. (Photographs courtesy of Mary Nitsche.)

U.S. senator Richard Durbin made multiple appearances at the South Side Irish Parade, always stopping first at Jack and Maureen Kelly's house. In 1996, above, Durbin posed with Jack Kelly's mother Millie Olsen, his daughter Colleen, and his wife Maureen in front of Illinois state representative Tom Dart's float. Behind them are June Gleason, Quinlin Kelly, and Kylie Kelly. After the parade, Durbin also attended the Nitsches' post-parade party, along with Mary Alice Houlihan, Larry Nitsche, Cathy Fennell, and Susan Loftus. Durbin was elected to the senate in 1996 and currently serves as the majority whip. (Courtesy of Maureen Kelly.)

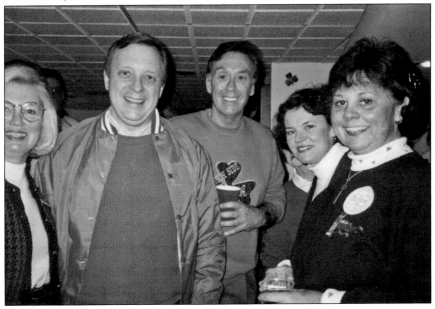

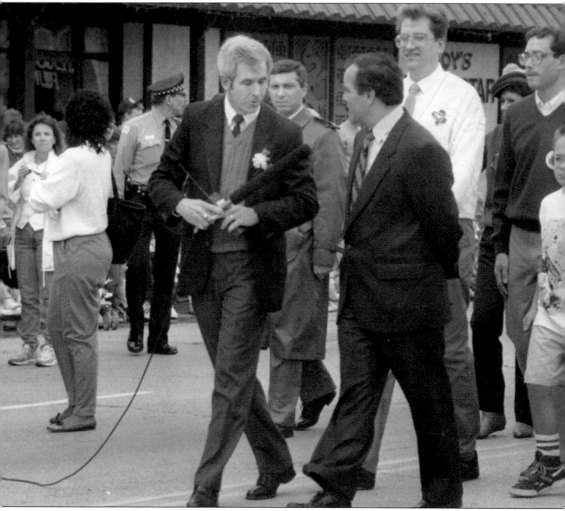

Cable broadcast team member and longtime member of the parade committee, Paul Poynton, interviews Richard M. Daley, then Cook County state's attorney, as he marches in the 1987 parade. Daley marched in several parades before he decided he would set Sundays aside to focus on activities with his family. (Courtesy of Paul Poynton.)

Wearing a green Irish cap, Cook County commissioner John Daley waves to the crowd at the 2009 parade. Daley is commissioner of the 11th district and was elected into office in 1992. (Photograph by Art Morgan; courtesy of the South Side Irish Parade Committee.)

In 2009, Cook County sheriff Tom Dart smiles and shakes hands with the crowd. Dart grew up in Beverly in the St. Barnabas Parish and attended Mount Carmel High School. Dart was in the parade for many years, first as an Illinois state representative. Dart has made many positive headlines since being elected sheriff in 2006. In 2009, *Time Magazine* named Dart one of its 100 most influential people. (Photograph by Art Morgan; courtesy of the South Side Irish Parade.)

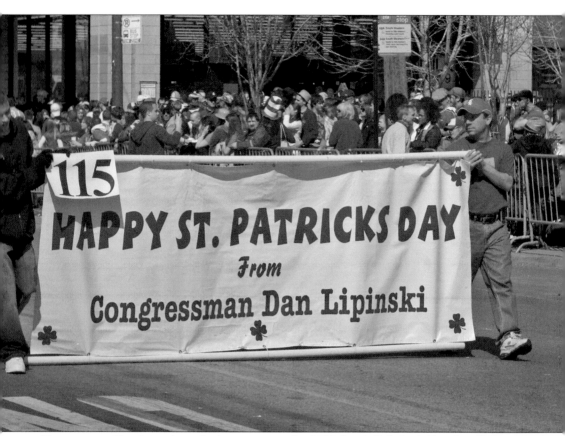

Congressman Dan Lipinski wished everyone at the 2009 South Side Irish Parade a "Happy St. Patrick's Day!" In 2006, Lipinksi's float malfunctioned, giving off a thick white cloud of smoke, sending firefighters to the rescue. The *Chicago Tribune* reported that the crowd cheered mercilessly for the mishap. (Photograph by Art Morgan; courtesy of the South Side Irish Parade Committee.)

Ten

END OF AN ERA

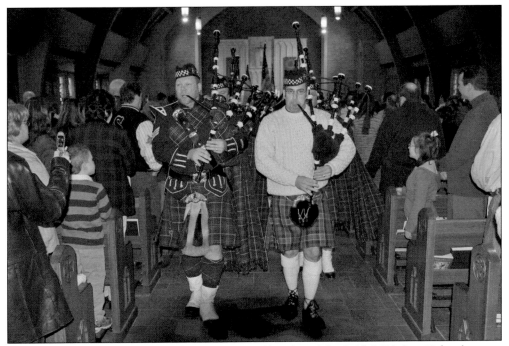

Bagpipers play out the processional at St. Cajetan Church on March 15, 2009. Just 10 days later, on March 25, the parade committee announced they were ending the South Side Irish Parade after 31 years. In a release, the committee said the neighborhood parade had grown to international proportions, and the volume of people was too much for the area to handle. (Courtesy of the South Side Irish Parade Committee.)

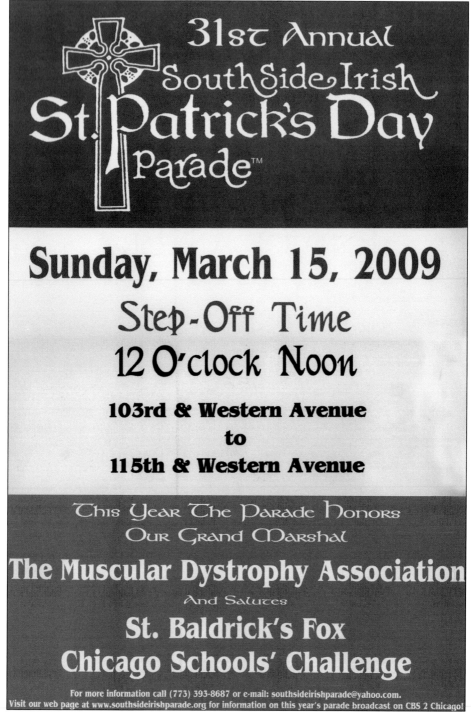

31st Annual SouthSide Irish St. Patrick's Day Parade™

Sunday, March 15, 2009

Step-Off Time
12 O'clock Noon

**103rd & Western Avenue
to
115th & Western Avenue**

This Year The Parade Honors
Our Grand Marshal

The Muscular Dystrophy Association

And Salutes

**St. Baldrick's Fox
Chicago Schools' Challenge**

For more information call (773) 393-8687 or e-mail: southsideirishparade@yahoo.com.
Visit our web page at www.southsideirishparade.org for information on this year's parade broadcast on CBS 2 Chicago!

This is the final poster from the parade—a far cry from the first announcements placed in mailboxes 31 years prior. The oversized posters had become a fixture of the parade, and some families kept them as souvenirs. When the parade was cancelled, many wished they had held on to theirs. (Courtesy of Marianne Coakley.)

In 2009, the parade committee took a group photograph during a farewell party for the parade at Gaelic Park. From left to right are (first row) Ed Haggerty, Jack O'Connor, Kevin Norris, Jim Davoren, Jack McNicholas, Pat Coakley, and Mike Hayes; (second row) Maureen Kelly, Sheila Norris, Mary Ann McNicholas, Sue Nelson, Mary Ellen Nedved, Marianne Coakley, and Mary Beth Sheehan; (third row) Dick Norris, Jim McKeever, Megan Haggerty, Beth Hickey, George Nedved, Mary Hendry, Peggie Rafferty, and Jackie Davoren; (fourth row) Bill Gainer, Willie Winters, Jim Malloy, Jack Kelly, Rich Fitzgerald, Mary Sheridan, Bill Hickey, Jim Sheridan, Bill Letz, George Hendry, and Bob Rafferty. (Photograph by Art Morgan.)

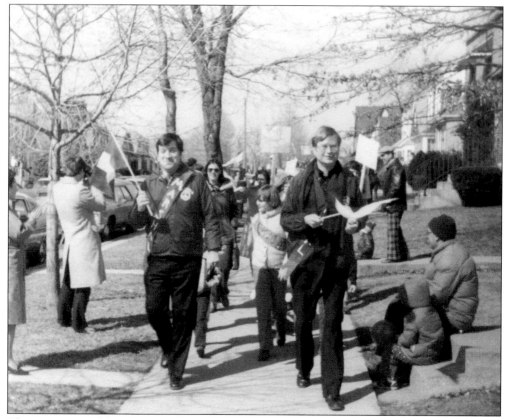

The excitement of the South Side Irish Parade took off with other ethnicities and inspired a group of South Side Italian and Polish residents to have their own parade. The St. Joseph Parade was held on March 22, 1981, in honor of the Feast of St. Joseph. Pictured here are the former pastor and associate pastor of St. Cajetan, Fr. Victor Sivore and Fr. Ron Navoy. The Wee Folks came out and cheered on their neighbors at the parade. They included a young girl who showed her support with a sign that read, "South Side Irish Support St. Joe's Sunday Strollers." The parade lasted for a couple of years before disbanding. (Courtesy of Marianne Coakley.)

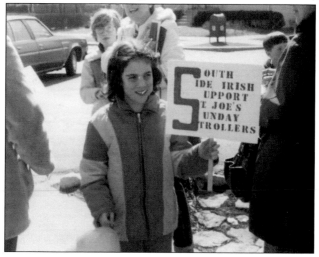

No one could have guessed the South Side Irish Parade would go beyond the blocks of Washtenaw and Talman, but it did. In fact, it extended out of the country. On March 16, 2009, U.S. troops stationed in Baghdad, Iraq, held their first St. Patrick's Day Parade in the appropriately named Green Zone. The parade was organized by First Sergeant Scott McWilliams, a South Side native. The Gulf Region division is comprised of the U.S. Army Corps of Engineers, and the 416th Theater Engineer Command is from Darien, Illinois, just west of Chicago. The South Side Irish Parade Committee, along with the Compadres, a local nonprofit organization established to support military chaplains, adopted the troops and sent about 30 boxes of festive items to liven up the event. The troops grabbed anything green and four vehicles performed two laps around the compound, the article said. They then handed out green trinkets and other paraphernalia to loud applause. (Courtesy of the USACE.)

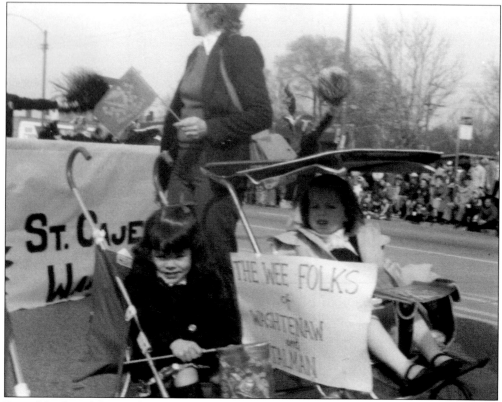

Part of the fun of the parade is watching families grow up. Many of the Wee Folks of Washtenaw and Talman are married with Wee Folks of their own. They've even got their own moniker, "The Wee Wee Folks!" In 1983, above, Wee Folks members Elizabeth Hughes and Mary Kate Hayes, both 2, rode in style down Western Avenue with a little push from Pat Hayes. In 1998, below, the girls were 18 and marched the parade route again, with Elizabeth to the left, and Mary Kate on the right. (Courtesy of Kathleen Hughes.)

The parade was celebrated annually on the Sunday before St. Patrick's Day and was never shut down due to weather. The photograph above from the mid-1980s shows the parade marched on in the rain, but even more impressive is that a large crowd still came out to support everyone. The weather was much clearer in 1994, when thousands came out for the parade, including 800 graduates of St. Leo, Brother Rice, and St. Laurence High Schools, pictured below. (Courtesy of the South Side Irish Parade Committee.)

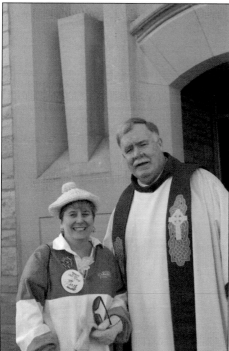

The Reverend Martin O'Donovan, above left, is pictured in 1986 with Sr. Sean Morley, O.P.; and Rev. Gene Smith, all of whom were not only fixtures at St. Cajetan, but at the parade as well. Reverend O'Donovan and Reverend Smith had both been involved with the parade in the early years and served on the parade committee. Sister Sean is the former principal of St. Cajetan and gave students the day off from school the day after the parade. Even after Reverend O'Donovan left St. Cajetan for St. Christina parish, he still came back to say mass at St. Cajetan before the parade, as shown in the photograph from 2009 at left. (Courtesy of Peggie Rafferty and the South Side Irish Parade Committee.)

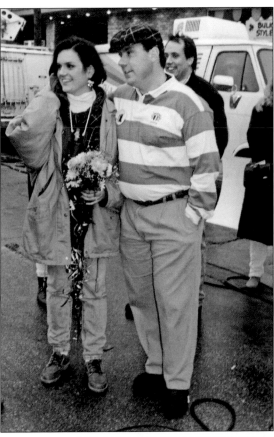

The parade saw many heartfelt moments. In 1996, South Side resident Toby Murphy popped the question to his girlfriend, Jennifer, at the parade. The couple was interviewed by the broadcast cable team about the big surprise. In 1998, Chicago firefighters stopped the line of march to salute fallen brothers Anthony Lockhart and Patrick King, who died one month before while trying to stop a fire at Beverly Tire, located at 106th Street and Western Avenue. Wreaths were placed in their names at the location. (Courtesy of the South Side Irish Parade Committee.)

Coverage of the parade also blossomed as the years went on. In the beginning, only cable television would carry a live feed of the parade. The first parade broadcast was taken from the roof of the Western Pump Tap at 110th Street and Western Avenue in 1981. In the photograph at left, South Side resident Peggy Rourke holds an interview in the reviewing stand as the parade marches past in 1986. In 2009, local affiliates covered the parade, including local NBC Channel 5 reporter Sharon Wright, who interviewed a family attending the parade in the picture below. (Courtesy of the South Side Irish Parade Committee.)

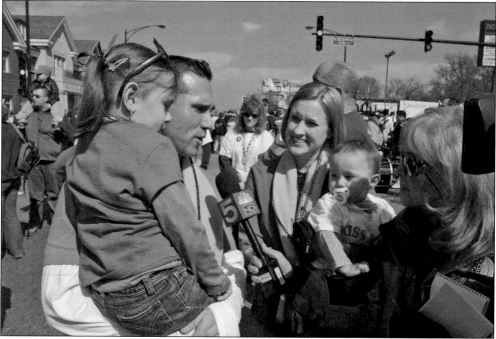

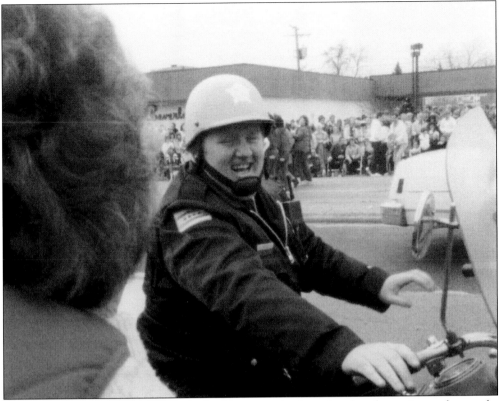

The controversy in 1981 over the lack of police protection brought a lot of attention to the parade. Police were present at every parade from 1982 to 2009. In the photograph above, Chicago police officer Mike Joyce rides by while securing the parade route in the early 1980s. In 2009, below, the large parade crowd brought out the mounted police to help keep spectators orderly. (Top photograph courtesy of Peggie Rafferty; bottom photograph by Nora Houlihan.)

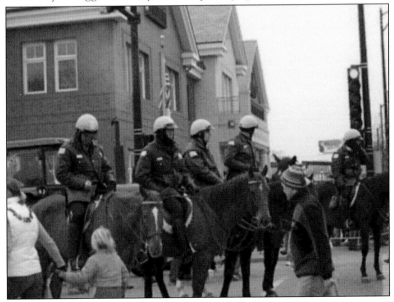

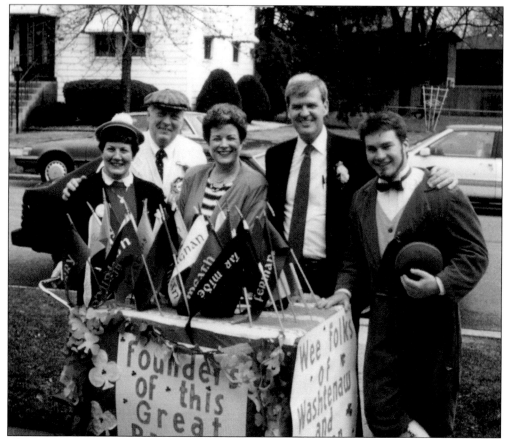

The tradition that Marianne and Pat Coakley, left, and Mary and George Hendry, right, began in 1979 sparked a sensation that caught on rapidly with residents all over the South Side. May 31, 1990, was the last time Pat Coakley, left, and George Hendry, right, had their picture taken together. The parade co-founders were in Memorial Hall, the basement of St. Cajetan, for the eighth grade graduation party. The Hendrys were leaving the following day for Ireland. As the two couples said goodbye, Pat Coakley hugged them and said, "I love you guys." While in Ireland, the Hendrys got the devastating news that Pat Coakley had died of a heart attack. While he didn't get to see the enormity of what the parade had become, Pat Coakley's spirit lived on in the parade for years to come. (Photographs courtesy of Mary Hendry.)

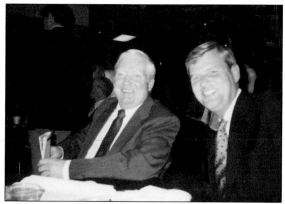

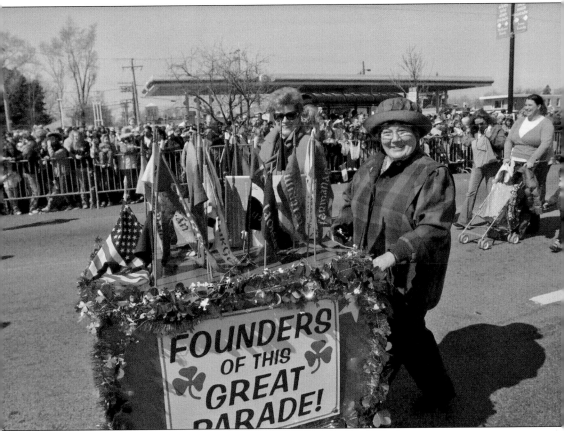

In 2009, Mary Hendry, left, and Marianne Coakley, right, pushed the original parade float down Western Avenue one final time. For 31 years, it had been Marianne who guided the baby buggy, covered in green and holding the 26 county flags of Ireland, along the parade route. In going over the history of the parade, both women laughed and said they had never actually seen the parade because they had been in it every year. Although both said they were saddened that their grandchildren, dubbed "The Wee Wee Folks," would not be able to march with the families in the parade, they also understood it was probably time for the tradition to come to an end. (Photography by Art Morgan; courtesy of the South Side Irish Parade Committee.)

House parties before and after the parades were very common in thousands of homes across the South Side neighborhoods on parade day. The first party was held in Hendry's garage and basement, where kids munched on pop, Twinkies, and cookies. As the years progressed, parties became more organized, with families setting up buffet tables, as pictured below. People opened their homes to family, friends, and strangers. Anyone was welcome to stop by for a bite and a pint. (Courtesy of Mary Hendry and Nora Houlihan.)

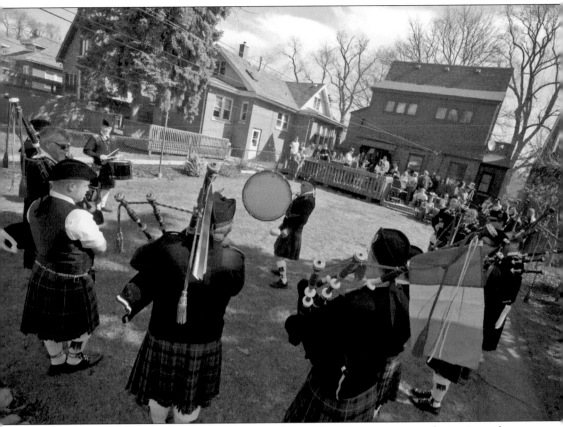

Over the years, some house parties grew pretty big, with many guests meandering in and out of open houses. In 2009, the St. Andrew's Society of Central Illinois Pipes and Drums stopped by to entertain the crowd at Jack and Maureen Kelly's house. The group has been a part of the Springfield community since 1989. The great weather brought guests out to their back porch, as the band played a few Irish tunes in the backyard. (Photograph by Jason Brown.)

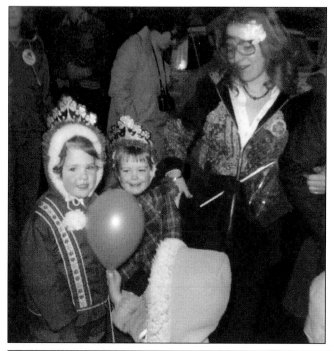

Wee Folks Bess Hendry and Annie Coakley enjoyed the 1980 parade with Annie's cousin, Mary K. Gleason. The 2009 parade was just as exciting for Keighley Armstrong, 7, of Oak Lawn. The fun and excitement children had at the parade brought them back every year. Many who attended the first parade have grown up, married, and brought their own children to the event. The parade was successful because it achieved what it set out to accomplish—to bring friends and families back to the old neighborhood and celebrate their Irish heritage. (Top photograph courtesy of Mary Hendry, bottom photograph by Jason Brown.)

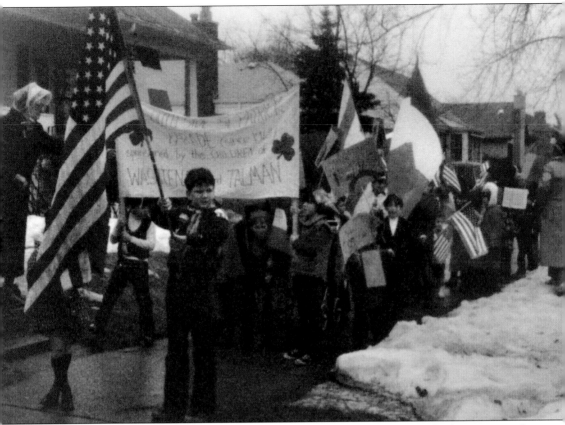

To appreciate the scope of the parade, one has to look back at what it was in the beginning and how it finished in the end. The parade lined up in dreary weather outside the Coakley house on Washtenaw Avenue with the 17 members of the Wee Folks. About 50 neighbors, friends, and family came out of their homes to watch the parade take place. The kids dressed up in their best Irish outfits, much of which were hidden under layers of jackets, hats, and gloves. There was a St. Patrick, a St. Cajetan, and a Parade Queen and they marched twice around the blocks of Washtenaw and Talman. Afterward, they were treated to some pop and cookies and went to sleep that night having had a great day at a neighborhood parade. (Courtesy of Kathleen Hughes.)

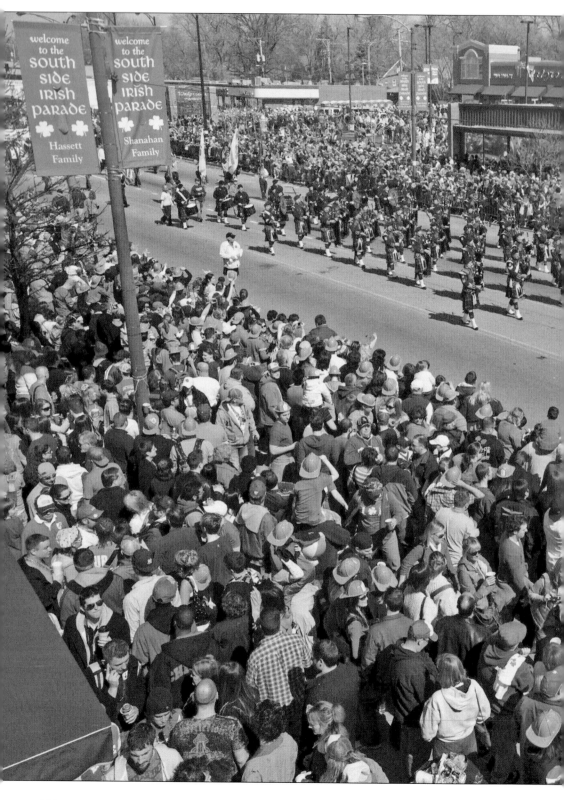

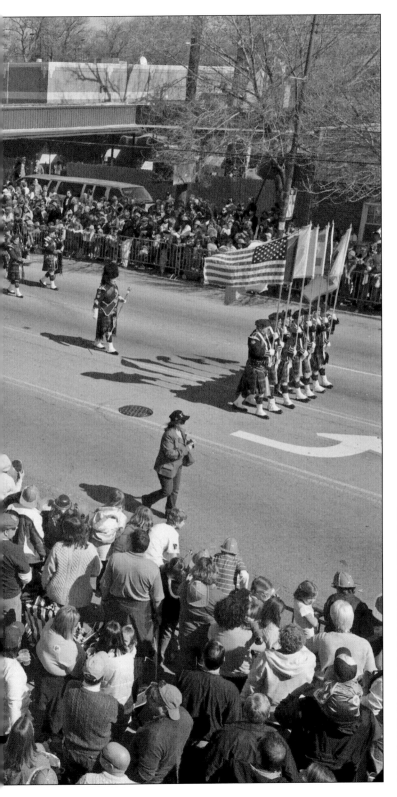

In 2009, the parade crowd swelled to nearly 300,000 people. Streets and sidewalks along the route were jam-packed with kids, parents, grandparents, teenagers, and college students, and buses from all over brought in even more. After the tremendous turnout of the last year, the parade's overwhelming popularity became too much for the neighborhood, and it had to end. (Photograph by Jason Brown.)

Another successful parade day ends for this little one as he rides in his red wagon down Western Avenue. The handwritten sign wishes everyone a Happy St. Patrick's Day! (Courtesy of the South Side Irish Parade Committee.)

The South Side Irish Song

Written by Tom Walsh, Tom Black and Terry McEldowney

We're the Windy City Irish, where the craic is always best
Where every day is Paddy's Day and everyone's a guest
If you're Irish on the North Side, or Irish on the West
Welcome to the South Side – come join our Irish Fest!

(Chorus) We're the South Side Irish as our fathers were before
We come from the Windy City and we're Irish to the core
From Bridgeport to Beverly from Midway to South Shore
We're the South Side Irish - Let's sing it out once more!

Our parents came from Mayo, from Cork and Donegal.
We come from Sabina, St. Kilian's and St. Gall
St. Leo, Visitation, Little Flower and the rest.
The South Side parishes are mighty-they're the best!

Chorus

We live on the South Side-Mayor Daley lived here too
The Greatest Irish Leader that Chicago ever knew
he was always proud of his South Side Irish roots!
So here's to Hizzonor to his memory we'll be true.

Chorus

We sing the songs our fathers sang when they were growing up
Rebel songs of Erin's Isle in South Side Irish Pubs
and when it comes to baseball-we have two favorite clubs
The Go-Go White Sox... and whoever plays the Cubs!

This is the South Side Irish Song, written in 1984 by Tom Walsh, Tom Black, and Terry McEldowney. The song came about due to the popularity of the term "South Side Irish" and only took about four hours to write. (Courtesy of Terry McEldowney.)

DISCOVER THOUSANDS OF LOCAL HISTORY BOOKS FEATURING MILLIONS OF VINTAGE IMAGES

Arcadia Publishing, the leading local history publisher in the United States, is committed to making history accessible and meaningful through publishing books that celebrate and preserve the heritage of America's people and places.

Find more books like this at
www.arcadiapublishing.com

Search for your hometown history, your old stomping grounds, and even your favorite sports team.